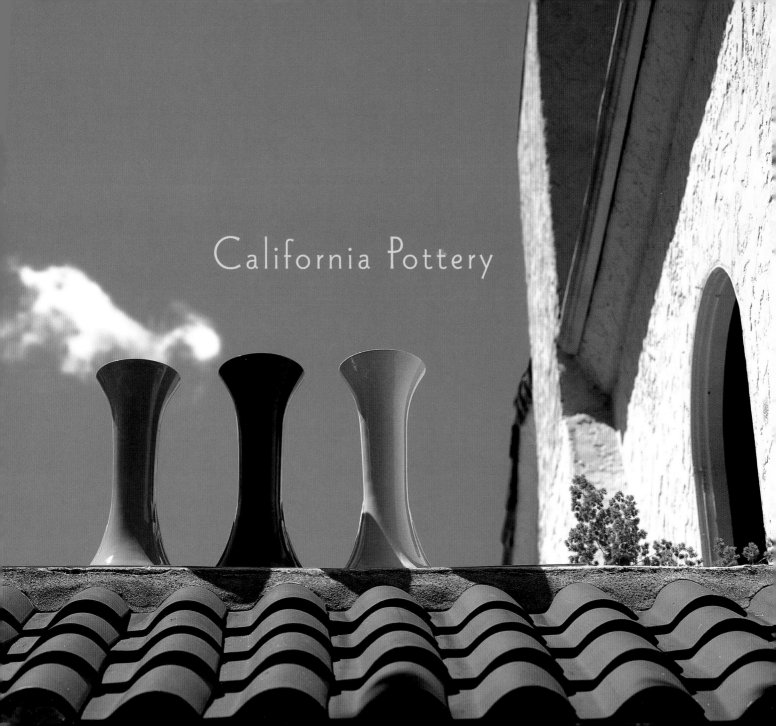

California Pottery

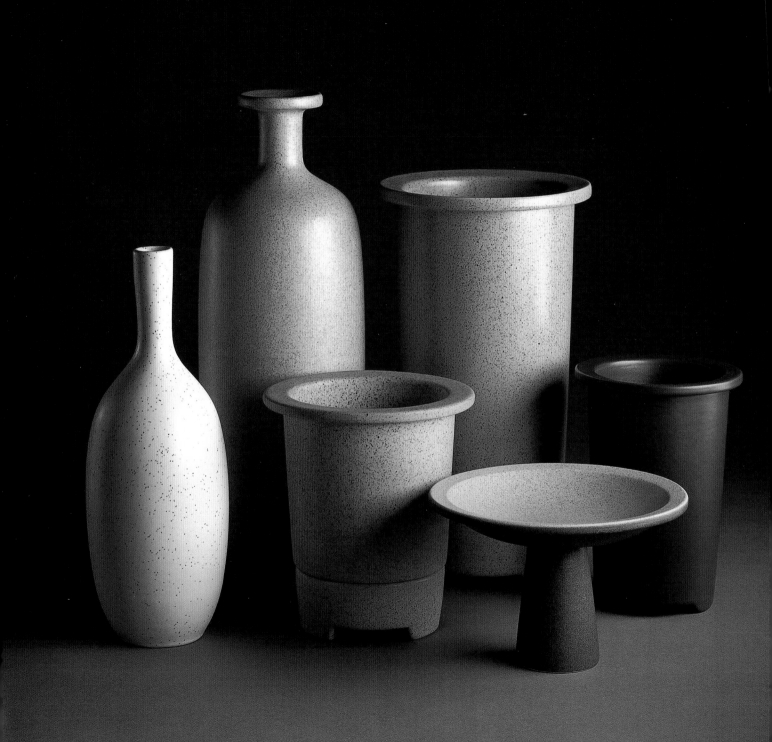

California Pottery:
From Missions to Modernism

By Bill Stern Photographs by Peter Brenner

CHRONICLE BOOKS
SAN FRANCISCO

Dedications

To my mother, for my appreciation of color, and my father, for the need to write.

To Steve Uribe whose help made it possible, and to Betsy Amster who believed in it.

And to the California Pottery researchers without whose pioneering work this book could not have been written, among them: Hazel V. Bray, Jack Chipman, Steve Conti, Deleen Enge, A. W. Fridley, Carl Gibbs, Maxine Nelson, Jim Pasqualli, Bill Reed, Lee Rosenthal, Douglas M. Stanton, and Mitch Tuchman. And to the dealers who turned the first generation of collectors on to California Pottery: Jack Chipman, Barbara Jean Hayes, Ron Hillman, Virginia Jacks, Gloria Samario, Judy Stangler, and Buddy Wilson.

—Bill Stern

To my parents, Jewell and Allen Brenner, and my wonderful support team: Rosanna, Rachel, and Romy Brenner.

—Peter Brenner

Page 1. Pacific Pottery, Los Angeles. Floor vases. c. 1936.

Page 2. Metlox Potteries, Manhattan Beach. Left to right: bud vase. bottle vase. flowerpot and saucer. cylinder vase. compote. flowerpot. Molded vessels by studio potter Harrison McIntosh (b. 1914). Unmarked. 1955. Several examples were shown in the 1955 California Designed exhibition at the Long Beach Municipal Art Center. but they were not put into production.

Page 3. Vernon Kilns, Vernon. Rippled platter by May and Vieve Hamilton. 1936.

Library of Congress Cataloging-in-Publication Data:

Stern, Bill
 California pottery : from missions to modernism / by Bill Stern ; photographs by Peter Brenner.
 p. cm.
 ISBN 0-8118-3068-3
 1. Pottery, American—California—Catalogs.
 2. Pottery—20th century—California—Catalogs.
 I. Title.
NK4025.C2 S74 2001 00-057093
738'.09794'0904—dc21 CIP

Printed in China
Designed by Laura Lovett
Typeset in Horley Old Style, Capone Light, Wade Sans Light, and Stymie Obelisk

Distributed in Canada by Raincoast Books
9050 Shaughnessy Street
Vancouver, British Columbia V6P 6E5

10 9 8 7 6 5 4 3 2 1

Chronicle Books LLC
85 Second Street
San Francisco, California 94105

www.chroniclebooks.com

Contents

**Vernon Potteries
(later Vernon Kilns), Vernon.**
Beehive kilns at left. 1931. Photo:
Museum of California Design.
(Gift of Meredith Brody)

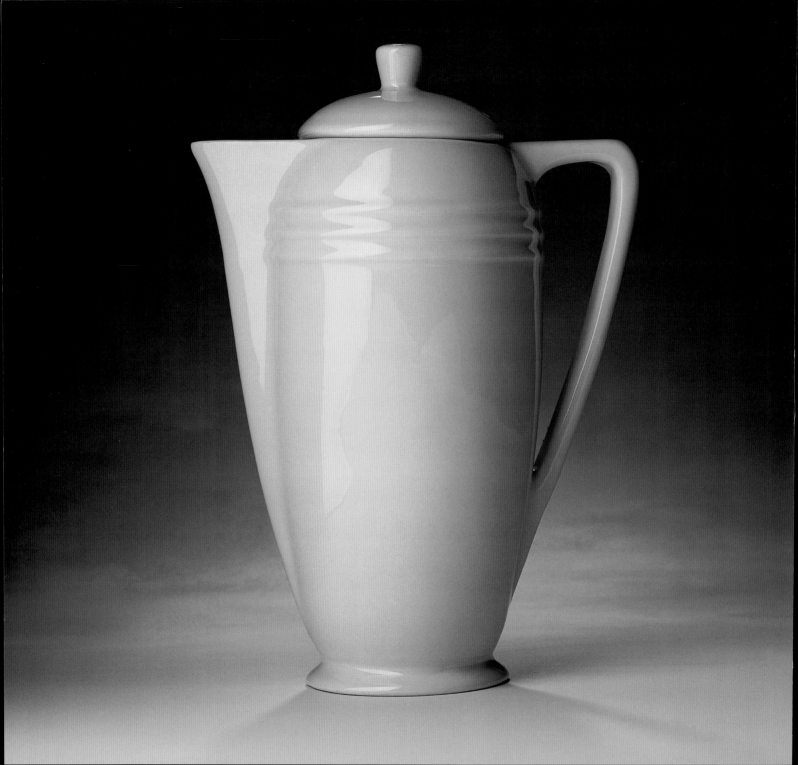

Pacific Pottey, Los Angeles
Hostessware demitasse
coffeepot. c. 1934.

Foreword

For years after I moved to California from New York City not only was I completely ignorant of California's pottery, I didn't feel that I really lived here. Los Angeles wasn't a city to me; it was a place that seemed to have risen more out of modern myth than history.[1] Then one of my neighbors who was moving to a ranch in Texas offered to sell me a few things, among them a set of solid-colored dishes like nothing I'd ever seen before. And though I had plenty of Japanese stoneware at home, some force—abetted by my friend Barbara, who had furnished her home and herself in vintage garage sale finds—made me buy them.

From there on it sounds like one of those fantasy short stories in which a seemingly insignificant act has extraordinary consequences. I carried the dishes up to my Spanish Colonial Revival/Art Deco apartment (you know: terra-cotta tile roof, ziggurat fireplace), took some books out of a sideboard, put the dishes in their place, and was transfixed by the colors. Then I heard the sideboard say: "More!" Of course that "insignificant" purchase led to my acquiring more pieces of pottery, several thousand more, in fact, enough to earn me a chapter in the book *Magnificent Obsessions*.[2]

The turning point between a bit of home decorating and a calling was my discovery that Vernon Kilns, which had made those first orange, green, blue, and yellow dishes in Vernon, California, in the 1930s, was merely one of many companies that made what I soon learned to call "California Pottery." I subsequently learned that this rubric covered not only dishware but also agricultural pottery, garden pottery, and tiles, that it was not limited to pieces from the thirties but had roots in the eighteenth century, and that its most productive

period continued well into the 1950s. A compulsion to learn still more led me to research and write articles about California Pottery, and as I became acquainted with its historians, collectors, and designers I developed a deep and comforting involvement with my adopted state—both its past and its present—and I finally began to feel that I was a citizen of California.

As I researched California's potteries further, I got to know some of the individuals who were responsible for what I recognized to be an astonishing period of design creativity. But, alas, the names of some of the creators are unknown, and we may never know things as basic as when and where they were born or died. Recognized artists like the great tile maker Ernest Batchelder, the eminent illustrator Rockwell Kent, and acclaimed ceramic designers Edith Heath, Eva Zeisel, and Russel Wright designed some California Pottery. But other remarkable work was produced by such unheralded talents as Rufus Keeler, Durlin Brayton, Gale Turnbull, William "Harry" Bird, May and Vieve Hamilton, Jane Bennison, Frank Irwin, Barbara Willis, George James, and LaGardo Tackett. As our story-with-pictures of California Pottery unfolds, their contributions, along with those of other significant individuals—among them the Yankee who bought Malibu and the Chicago Cubs owner who bought Santa Catalina Island, both of whose properties would eventually harbor major potteries—will receive the attention they merit.

This book is a celebration of remarkable, even revolutionary, commercially produced pottery. It is the story of beautiful objects made for everyday use—tiles, dinnerware, vases, lamps, flowerpots—most designed and produced by unsung craftsmen and -women, and it is the story of some of the ways in which California design has influenced the way we live today.

—Bill Stern

Footnotes

1 "The newness of the land itself seems, in fact, to have compelled, to have demanded, the evocation of a mythology which could give people a sense of continuity in a region long characterized by rapid social dislocations." Carey McWilliams, *Southern California Country: An Island in the Land* (New York: Duell, Sloan & Pearce, 1946), p. 71.

2 Text by Mitch Tuchman, photographs by Peter Brenner (San Francisco: Chronicle Books, 1994).

Photographer's Foreword

I grew up in La Crescenta, near Glendale, California, where our everyday dishes were Franciscan earthenware made at the sprawling Franciscan plant we used to see when we visited Allen Wertz Candies across the street. As a wedding present, my wife Rosanna's parents gave us a set of Desert Rose dinnerware, but I didn't think of it as California Pottery until I saw examples of California-made pottery in the Arts and Crafts and Modernism shows at the Los Angeles County Museum of Art, where I work. Originally, I had looked upon it as a leftover from another generation. Then I realized that it was an important part of our culture.

What really changed the way I looked at California Pottery was photographing the book *Magnificent Obsessions*. I had the opportunity to see beautifully designed work. When seeing it all together I was surprised and impressed by the variety of colors and shapes of its design. I was also surprised by how many collectors are out there and just how much California Pottery they have amassed.

I'm not a collector. I'm tempted, but I haven't given in to it. I must say, though, that every time I see California Pottery, its beauty compels me to pick it up and touch it.

—Peter Brenner

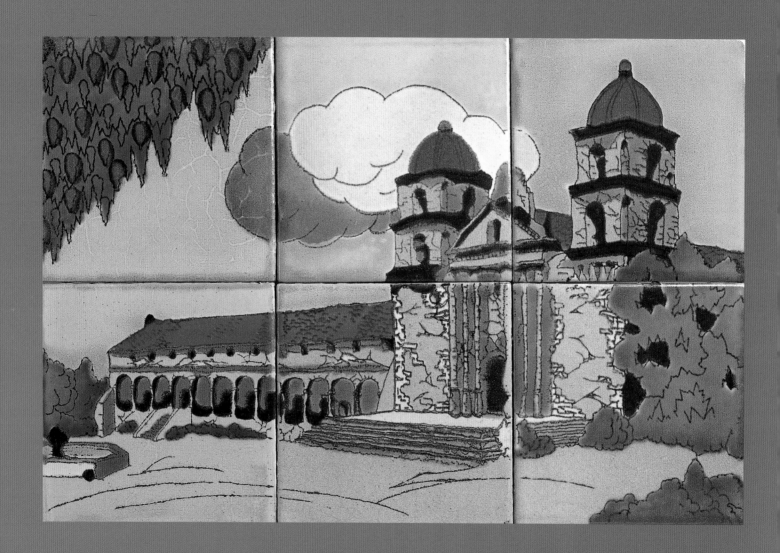

Introduction: Why California Pottery?

Taylor Tilery, Santa Monica
Tile panel with a romanticized
image of the Mission Santa
Barbara. c. 1920s.

Pottery is one of those things so fundamental to our lives that, like the roof over our heads, we barely give it a thought. This despite the fact that pottery is always a part of our lives: on our floors, walls, windowsills, porches, mantels, and dining tables, and in our cupboards. And if, as cultural observer Jeff Weinstein puts it, "we are what we eat off of," pottery must affect us profoundly.[1]

Practical pottery has been part of human culture for fifty thousand years or more: whenever important archeological sites are unearthed—in China, the Yucatán, even San Francisco[2]—it is pottery that makes the front-page news photo. Shards of unearthed clay vessels tell of cultures traded with, battles fought, and foods eaten. Here in California, the earliest known pottery multiples—terracotta pavers from about 1769—have been unearthed at the Mission de Alcalá, in San Diego. Contemporary pottery, of course, has its own stories to tell, and California's, formed out of the state's ample deposits of clay and talc, is no exception. California Pottery's shapes and designs are a narrative of the coming together of the cultures that contributed to making California as economically and culturally significant as many independent nations. They tell of the impact California has had, and continues to have, on how we live: from breaking down

the barrier between interior and exterior living to bringing about a democratic, color-splashed revolution at the American table.

Just as painted decorations on ancient pottery may depict scenes from mythology or history, so the decorations on California Pottery reflect life in America: the introduction of bright colors at the end of the 1920s followed a decade of large-scale immigration from Mexico; Catalina pottery exalted the abundant marine life in the waters around Santa Catalina Island; Rockwell Kent's images for a 1939 dinnerware service echoed the economic and social culture of the United States of his day, raising questions of class and race as they depict our nation's transition from an agrarian to an industrial economy. As has often been the case, California was playing a leading role in American culture.

By the teens of the twentieth century "California" had, in fact, become as marketable a designation as "Champagne"—a distinction no other part of the United States can claim—for even though "California" doesn't signify luxury the way Champagne does, the name "California" could, and still can, be counted on to get our attention: we expect it to be attached to something fresh, whether it's something new to use or pretty to look at or a whole new approach to life, for California's influence on the American lifestyle extends from Levi's to patio living, from hot tubs to iMacs to modernist pottery.

left to right
Mission San Diego de Alcalá. San Diego. Terra-cotta pavers— floor and patio tiles of baked clay like these—are the oldest extant pottery multiples made in California. c. 1769.

Mark: California Faience
Berkeley. c. 1925.

Mark: Ultra California
Vernon Kilns. Vernon. c. 1936.

Mark: Franciscan Ware
(Gladding. McBean & Co.)
Los Angeles. c. 1950.

Mark: Metlox Potteries
Manhattan Beach. c. 1932.

Early in the last century California had become what the movie industry calls "The Name above the Title," the star whose familiar identity draws moviegoers to a new film. That marketability of the state's name was not lost on California's then young pottery industry: in 1911 a company making tiles near San Diego was calling itself "California China Products," and in the 1920s Americans could read "California Faience" on the bottoms of elegant, nationally marketed tiles, vases, and bowls. In the 1930s dinnerware patterns with names like Casa California, Early California, Modern California, and Ultra California were being sold in department stores across the country. By 1948, "California" or "Calif." or simply "Cal." was proudly included in the marks of some six hundred potteries, both large and small. Dozens of them were represented on the whole-sale level by Registered California, a trade organization that, in the late 1940s and early 1950s, offered "a kind of Good Housekeeping Seal of Approval to California-made household wares"[3] and promoted them at trade and giftware shows in New York, Chicago, Pittsburgh, and elsewhere.

It has been speculated that California's propensity for uninhibited innovation is a result of the early settlers' having been liberated by crossing endless deserts,[4] or the state's early geographic isolation,[5] or even the purported periodic lifting up of the United States from the northeast corner, which is said to

result in all the "unattached fruits and nuts rolling out there." Whatever factors may have been at play, California has long been "the promised land," a land of opportunity and a magnet for the ambitious and the talented (and the flim-flam artists) seeking an outlet for their abilities. Thus the Golden State has been a microcosm of the United States itself, but in addition to bene-fiting from immigrants from abroad, California has also benefited from immigrants from the rest of the country. Or as James J. Rawls puts it in *California: A Place, A People, A Dream*: "California is America's own New World."[6]

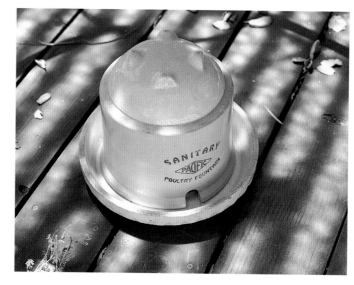

Pacific Pottery, Los Angeles

Poultry Fountain. c. 1920s. Poultry fountains served California's important chicken farming industry. To use: turn dome upside down. fill with water. place inverted tray on top. and turn rightside up: water will rise only to top of tray. As chickens drink. prevented from fouling the water by the narrow distance between tray and dome. reserve in dome will keep refilling the tray.

The development of California Pottery, a regional distinction unique in the United States, certainly owes much to the state's start-all-over-from-scratch independence from the country's East Coast cultural centers. For, as one observer said: "A lot of our potters are so new they don't know yet what can't be done, so they go ahead and do it."[7]

In the late nineteenth and early twentieth centuries, the European dominance of American culture affected the character of pottery-making in California. But before long, Californians took to finding their own sources of inspiration, not only in the extremes of the local landscape and the extravagance, especially in Southern California, of the largely imported flora (from Mexico and elsewhere), but also in the cultures that California—unlike the rest of the United States—had the most direct interaction with: that is, Mexican and Asian.

Through the early part of the twentieth century, its economy bur-

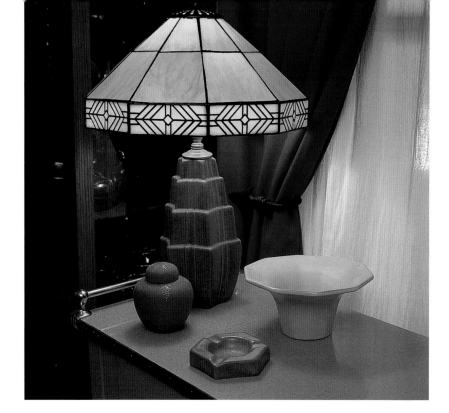

left
California Faience, Berkeley

Ginger jar, terra-cotta bisque
with a grapevine motif (left),
1920s; bowl (right), 1920s; ashtray
(center, foreground), c. 1920s.

California Porcelain, Millbrae

Lamp base, (center), c. 1925.

right
Robertson Pottery, Los Angeles

Vases in classic Chinese shapes.
c. 1930s.

geoned, even though rail links were relatively new and cross-country roads were just being constructed. Although the state was dependent on the importation of goods—lumber from the Northwest, manufactured goods from the Midwest and East, luxury goods from Europe and Asia—a homegrown culture flourished. Ample evidence is to be found in the wealth of architecture of the Mission and Spanish Colonial Revival and the California bungalow styles, in the Plein Air school of painting, and, in the decorative arts, in the Arts and Crafts style, which dominated pottery production well into the teens.

The major California Pottery companies of the teens and twenties were manufacturers of plain, utilitarian items for farm and home use, while others were makers of highly sophisticated glazed tiles for furniture and architectural uses. During that period, the Lincoln and Tropico plants of the now 126-year-old Gladding, McBean & Company—one of the oldest potteries in the United

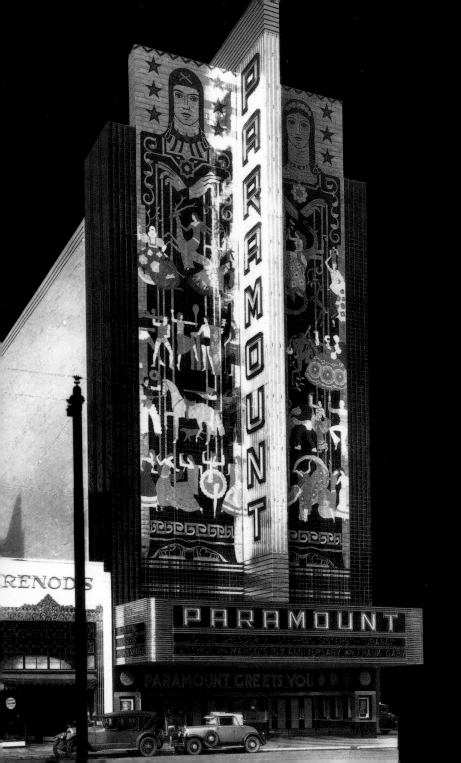

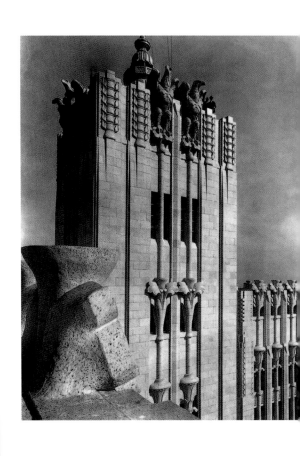

16

far left
Gladding, McBean & Co., Lincoln
Terra-cotta cladding.
Paramount Theatre. Oakland.
Timothy Pflueger and James
R. Miller. architects. 1931.
Photo: Gladding. McBean & Co.

left
Gladding, McBean & Co., Lincoln
Terra-cotta cladding (3,200
tons). Pacific Telephone and
Telegraph Building. San Francisco.
Miller & Pflueger. architects. 1924.
Photo: Gladding. McBean & Co.

States—not only made garden terra-cotta but created the massive terra-cotta cladding for major buildings in Los Angeles, San Francisco, Sacramento, San Diego, Oakland, and Fresno, California; as well as Portland, Oregon; Seattle; Salt Lake City; Kansas City; Honolulu; Sydney; and Tokyo.

Two occurrences more than a decade apart—San Diego's Panama-California International Exposition of 1915 and the beginning of large-scale dinnerware production in California in about 1930—revolutionized pottery design in the Golden State. Bertram Goodhue's New York–based architectural firm based its designs for San Diego's exposition on the Spanish-Moorish style and ordered buildings ornamented with the kind of geometric-patterned tiles that had been used in Spain since the eighth century, when the Moors occupied much of the Iberian Peninsula. Soon tileries throughout California were incorporating similar designs in their wares. The rich, opaque Moorish glazes paved the way for the *next* big event: In about 1930, several California potteries suddenly began applying the glazes to house and garden wares, but in colors attuned to the Mexican palette.

When Catalina Pottery, manufacturer of bricks and roof and patio tiles; J. A. Bauer Pottery Co., known for its gardenware; and Pacific Clay Products, producer of agricultural stoneware, entered the colored pottery market along with craftsman Durlin Brayton in about 1930, their efforts looked like a design revolution, but it was a social and economic one as well. Their new wares, in addition to being inexpensive, expressed a kind of pottery populism, an early example of the American propensity for allowing commercial or "low" culture to rise to the level of art, although it would be more than a half a century before California Pottery was recognized as such.

When Bauer, Pacific, and other major companies abruptly entered

the dinnerware market, they had to come up with hundreds of new shapes lickety-split, shapes for everything from dinner plates to coffee cups, butter dishes to teapots, and honey pots to ashtrays and vases. In addition to adaptations from other cultures—Chinese, Japanese, and Mexican, as well as French, English and early American—they solved their design problems with ingenuity and even wit. Unrestrained by tradition, many of their most imaginative shapes are unexpectedly witty adaptations of forms previously made of materials other than clay. We'll show, among other examples, how Catalina Pottery remade the *molcajete*, the Mexican lava-stone corn grinder, into a shrimp cocktail server; the relationship between Brayton-Laguna's oval serving bowl and a Central American wooden vessel; and how Pacific Pottery (a division of Pacific Clay Products) transformed the nineteenth-century, enameled-metal coffee pot that used to hang over prairie campfires into a clay beverage server.

A little later in the 1930s, when California's solid colors were being copied by Eastern companies, the state's potteries found no contradiction in putting their crude raw material into the service of Art Deco, Streamline, and Zigzag Moderne, whose designs had come out of the die-cut precision of the machine age. Even those shapes that incorporated the aerodynamic lines of modern transport and had originally been created for chrome or other metals were successfully transformed by California potteries into dramatic, if sometimes improbable, clay vessels.

There's no question that the Great Depression was decisive in popularizing California Pottery. Attractive but inexpensive pottery allowed masses of Americans who were affected by economic hardship to enjoy a measure of affordable, cheery luxury. By 1935, a number of California potteries—including Brayton-Laguna, Bauer, Catalina, Franciscan, Garden City, Pacific, Padre, Meyers (California Rainbow), Metlox, and Vernon Kilns—were producing inexpensive,

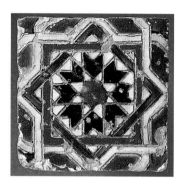

Hispano-Moresque tile.
Spain. (c. sixteenth century.)

California Building (detail).
Panama-California Exhibition.
1915. Bertram Goodhue. architect.
Photo: Norman Karlson.

solid-color dinnerware. At the same time several California potteries, looking for additional ways to reclaim the share of the national market that was going to Eastern imitators, added decoration to their products. Among them was Franciscan, whose Desert Rose dinnerware pattern,[8] introduced in 1941, became the largest-selling pattern ever sold in the United States by a single company.[9]

The momentum of ceramic design and production in California, as elsewhere, was halted by World War II. But as the war was ending, American creativity experienced a burst of new energy and California Pottery took off once again. From Barbara Willis' popular versions of studio pottery to Edith Heath's stoneware; from Frank Irwin at Metlox Potteries, inspired by Alexander Calder, to Architectural Pottery's Modernist gardenware, California was again leading the way in American commercial ceramic design. But then, with European and Japanese production rebounding after the war (and being encouraged by U.S. foreign policy considerations), and with other materials coming into vogue,[10] by the end of the 1950s California Pottery seemed to have fallen off the national design map. It might have stayed there if it hadn't been rediscovered by collectors, those "personal curators" whose accumulations would reveal the production of many of California's potteries to be extraordinary bodies of work.

Now, more than half a century after the Newark Museum and the Museum of Modern Art in New York began to exhibit industrial design—including such everyday objects as garden pottery and dinnerware—California Pottery is just beginning to take its rightful place in American design history. Although commercial California Pottery has been included in more and more American design exhibits in recent years, California Pottery: From Missions to Modernism, at the San Francisco Museum of Modern Art July 20 to October 14, 2001, is its first major museum retrospective. Why it has taken so long for this to

Malibu Potteries, Malibu

Salesman's sample box. c. 1927.

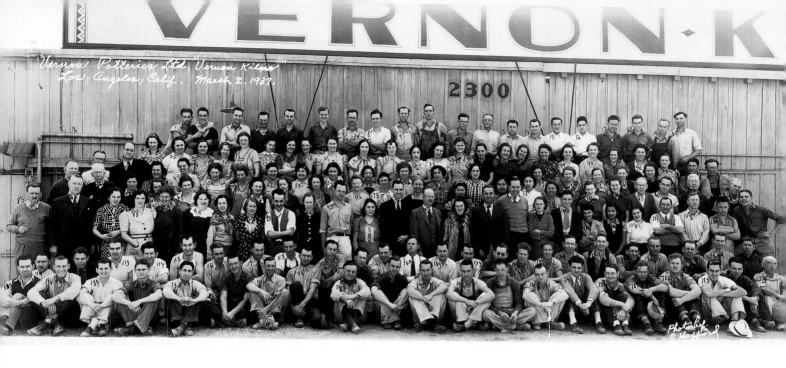

Vernon Potteries Ltd. "Vernon Kilns" Los Angeles, Calif. March 2, 1937.

above
Vernon Kilns Staff

Lower left, standing, in sweater,
Gale Turnbull, art director. Third row
from top, far left, in dark suit and tie,
Faye Bennison, president. Four rows
from top, right of center, in gray
three-piece suit, wearing eyeglasses,
William "Harry" Bird, designer.
Second row from top, sixth from
the right, in checkered blouse, Jane
Bennison, designer. March 2, 1937.

left
Jane Bennison

Vernon Kilns brochure, c. 1936.

Barbara Willis (right) and finisher Bernice Brown. North Hollywood. August 20. 1948.

Footnotes

1 Jeff Weinstein is fine arts editor, *Philadelphia Inquirer*. Conversation with the author, January 5, 2000.

2 Spanish colonial rooftiles, terra-cotta pavers and dinnerware, made locally in about 1790, were unearthed at the Presidio in 1993.

3 Royce Diener, whose company, Northington Industries, was part of Registered California. Conversation with the author, April 14, 2000.

4 William L. Fox, author of *Mapping the Empty*, at a panel discussion, Beverly Hills Public Library, February 23, 2000.

come about can be explained in part by Reyner Banham's assertion that "the very remoteness of Southern California, which had made the flowering of unin-hibited . . . inventiveness possible, also locked it away so that the claim [to world attention] could hardly be seen or heard."[11] This is equally valid for the rest of the state of California.

In virtually every housewares department and catalog today, from Pottery Barn to Ikea to Crate & Barrel, we see a legacy of California Pottery's Golden Age: the lineage of the solid-color pottery kitchenware, dinnerware and gardenware now used by millions of Americans, whether produced here or in other countries, can be traced straight back to the aesthetic and technological inven-tiveness of California's commercial potteries almost three-quarters of a century ago. Even though original California Pottery is now sought after by collectors and museums, its identity has been so completely usurped by imitators that to this day it is common to hear it said of California-made pottery—as I frequently do in my own home—"My, what beautiful Fiesta you have!" when that pseudo-California dinnerware was made, and is once again being made, in West Virginia. And the popularization of solid colors is just one aspect of the more than

forty-year Golden Age of California commercial pottery that Peter Brenner and I will survey here. We will show California Pottery early in the twentieth century mastering the sober Arts and Crafts style and embracing the romanticized missions and Spanish-Moorish embellishments of the Spanish Colonial Revival, flirting with the architectural and transport forms of Art Moderne and Art Deco in the 1930s, espousing what I've named the Rural Revival in the 1940s, and reaching its Modernist apotheosis in the 1950s with its echoes of Alexander Calder and Constantin Brancusi.

For this book, we have selected examples of California Pottery that we believe to be the most original, the most aesthetically pleasing, or the most telling representatives of this significant contribution to American design. Instead of presenting them in strictly chronological order we have divided this retrospective into chapters that highlight some of the major themes that characterize the work of California's production potteries. Chapter 1, "Paving the Way," opens at the beginning of the twentieth century, when pottery in California was imitating designs from Ohio and Europe, and goes on to California's first revolution in design and color. Chapter 2, "Color Crazed," paints a picture of the great solid-color revolution that swept America from West to East. Chapter 3, "Wit and Whimsy," and Chapter 4, "Streamline, Deco, Zigzag," reveal the shapes that made California Pottery so distinctive in the 1930s. Chapter 5, "Clay Canvases," is a gallery of decorated dinnerware. In Chapter 6, "Rodeos and Roosters," America's nostalgia for the Old West and the agricultural Heartland gets it due. And in Chapter 7, "Meeting Modernism," the future takes over, pre-

left to right
Vernon Kilns, Pacific, Padre, Pacific, Wallace, Pacific.

5 Reyner Banham, *Los Angeles: The Architecture of Four Ecologies* (Penguin Books, 1971, 1990 edition), p. 58.

6 In Sonia Maasik and Jack Solomon's *California Dreams and Realities* (Boston/New York: Bedford/St. Martin's, 1999), p. 9.

7 Department store buyer Eleanor Wilhelm in "Eating off the Rainbow," the *Saturday Evening Post,* November 19, 1949, p. 41.

8 " . . . the pattern was named 'Desert Rose' to connect it with California" since "products carrying the 'California' label had a great draw." Deleen Enge, *Franciscan: Embossed/Hand Painted* (Ojai: Deleen Enge, 1992).

Vernon Kilns, Vernon Kilns, Franciscan Ware (Gladding, McBean & Co.), Vernon Kilns, Pacific, Vernon Kilns, Pacific.

senting designs that still seem as new today as they did in the 1940s and 1950s. Finally in Chapter 8, "The End of the Rainbow," we flash forward and turn to the current practical aspects of our subject: where it is found, how it is used, and who is making it.

This overview of the work of hundreds of potteries and individuals over a period of more than fifty years is testimony that yet another of Reyner Banham's observations on early-twentieth-century California architecture also applies to California Pottery. It was "too functionally apt, environmentally ingenious, aesthetically original to have deserved its almost total neglect by the authoritative historians of the period."[12] Not only of that period: Peter Brenner and I think that more than a half a century of neglect is way too much.

9 Ibid. More Blue Willow may have been sold, but it was produced by several companies.

10 "... the break-even point cannot be met ... in today's market subjected to the impact of imports and other domestic competitive products such as plastics." Letter from Douglas Bothwell, Sales Manager, Vernon Kilns, to Mrs. Florence B. Miller, The Dinnerware Store, Tallahassee, Florida, regarding the closing of the company. January 17, 1958.

11 Banham, *Los Angeles: The Architecture of Four Ecologies*.

12 Ibid.

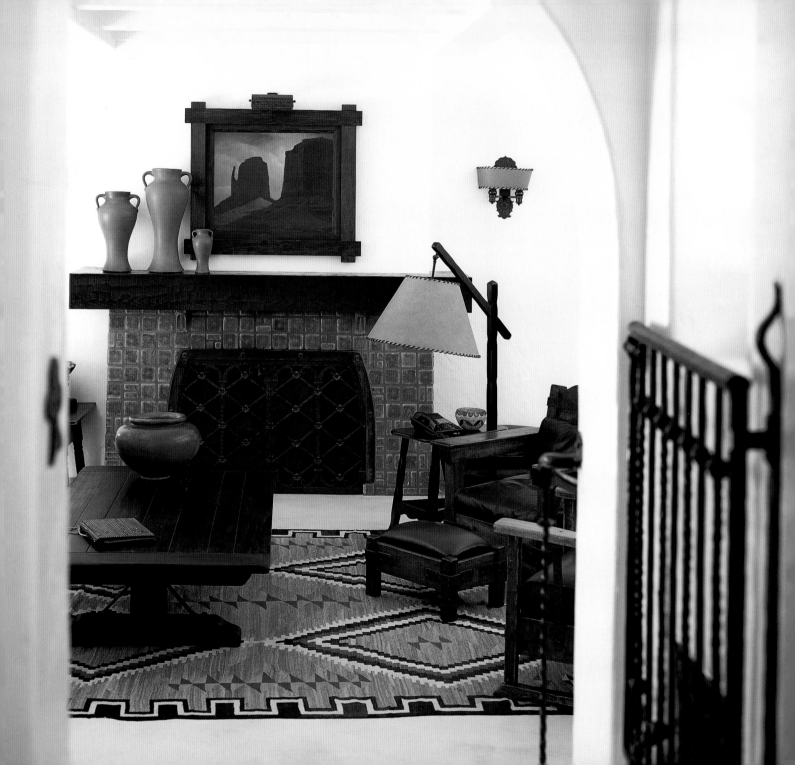

Chapter 1 : PAVING the WAY

**J. A. Bauer Pottery Co.,
Los Angeles**

Rebekah vases with Arts and
Crafts–style matte-green glazes.
1920s.

**California Clay Products Co.,
South Gate**

Fireplace tiles. c. 1928.

Gladding, McBean & Co., Lincoln

Blue urn. c. 1920s.

Like virtually every other peopled place on earth, California has a long pottery history: ceramics have been made here for millennia, by the indigenous peoples, the Spanish colonizers, and their American successors. Although commercial ceramics would eventually be made in many parts of the state, in the late nineteenth century and into the early twentieth century San Francisco and the surrounding area, the preeminent center of population and wealth in California at the time, nurtured the state's budding pottery industry.

Up to the early part of the twentieth century in California, as in the cultural centers of the East and Midwest, the models emulated by both American- and European-born potters were as a rule either neoclassical or Arts and Crafts, of English, French, or German pedigree. Among the earliest producers of cast "art pottery" (decorative vases and urns made in molds, as opposed to hand-thrown or studio pottery) was the Stockton Art Pottery. Situated about eighty miles east of San Francisco, in Stockton, it produced high-quality molded decorative vases, pitchers, and urns in shapes and glazes reminiscent of the Ohio potteries Weller and Roseville just before and just after the turn of the century. In 1911,

the influential Arequipa Pottery was established in Fairfax, some twenty miles north of San Francisco, by Frederick Hurten Rhead, of Hanley, England, and his wife, Agnes. Arequipa produced vases, bowls, and tiles under the direction of Rhead, who had previously worked at the Roseville Pottery. However, Rhead would have his greatest success twenty-five years after leaving Arequipa, designing the Fiesta dinnerware line for the Homer Laughlin Company of Newell, West Virginia. In Sacramento, the Panama Pottery Company, under the direction of Victor Axelson, produced art pottery, including vases, urns, and lamp bases, between 1914 and 1928.

By the teens significant commercial potteries had also opened in Southern California. In Los Angeles, Cornelius Brauckman was making elegant, cast vases for his Brauckman Art Pottery.[1] Tilemaker Ernest Batchelder set up shop in Pasadena in 1909, then moved to a larger facility in Los Angeles in 1920. His version of the Arts and Crafts style lent itself to the architectural styles pop-

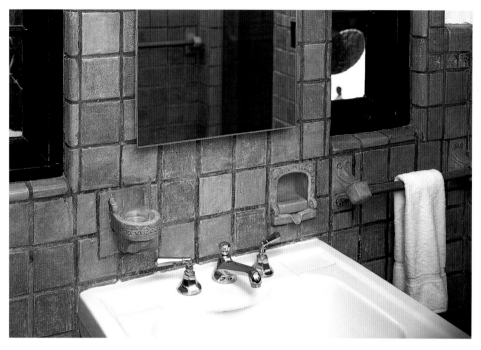

right
Batchelder Tiles, Los Angeles
Tiled bathroom (detail). c. 1927.

below
Batchelder Tiles, Los Angeles
Fireplace surround (detail).
c. 1927.

**J. A. Bauer Pottery Co.,
Los Angeles**
Fumigator (foreground). c. 1920.

ular at the time, notably Craftsman and Spanish Colonial Revival. Often utilizing monochromatic, matte glazes on deeply incised or raised flora, fauna, or landscape designs to great effect, Batchelder's nostalgic tiles ornamented fireplace surrounds, bathrooms, and indoor and outdoor fountains. Batchelder's work was so admired—and so well marketed—that important installations are to be found in venues as far-flung as Union Station in Chicago; the Christian Science Church in St. Petersburg, Florida; and the Chapel at St. Catherine's College in St. Paul, Minnesota.[2]

Here in California, roof tiles usually mean the unglazed terra-cotta half-cylinders that have been lending character to homes and civic buildings since Spanish colonial days and which proliferated during the post–World War I Spanish Colonial Revival. But California history is rich in other roof tiles, notably the glazed *wa-tong* that have been adorning the roofs of buildings and ornamental gates of the Chinese-American community since the nineteenth century. And

above left
Roof tile end caps (wa-tong).
China. c. 1990. Residence. San
Francisco.

above right
Gladding, McBean & Co., Lincoln
Terra-cotta roof tile (wa-tong)
end cap. pre-1915.

back then some of them were made by one of the nation's largest producers of architectural terra-cotta, Gladding, McBean & Company. Under several ownerships GMcB has been in business long enough—since 1875—for its output to span every style and almost every era in the modern history of California, more than that of any other pottery in the nation. Prior to making a very big splash in the dinner- and housewares market in the 1930s under the trade name Franciscan Pottery, then Franciscan Ware, GMcB was one of America's great producers of architectural terra-cotta, and gardenware, and is the only one remaining today.

When it came to cladding entire office towers in terra-cotta, Gladding, McBean & Company—with plants in Lincoln, about thirty miles northeast of Sacramento in Northern California, and in Tropico, the name of a former city bordering Glendale in Southern California—was number one. Numerous significant buildings wore or still wear GMcB's terra-cotta coats including: in Los Angeles, the gold-and-black Zigzag Moderne Richfield Oil Building (1928, razed 1968) and the Zigzag Moderne Bullocks-Wilshire (1929); in San Francisco, the Zigzag Moderne Pacific Telephone and Telegraph Company Building (1924); in San Diego, the Beaux Arts Spreckels Building (1924); in Oakland, the Art Deco Paramount Theatre (1931); in Kansas City, the Beaux Arts Orpheum Theater (1914, razed 1970); in Sydney, the Union Steamship Company Building (1916); and in Tokyo, the neoclassical Bank of Tokyo Mitsubishi Banking Hall (1922, razed c. 1977). For the interiors and exteriors of buildings, Gladding, McBean produced sculptured fountains that gurgled water from the mouths of mermaids, frogs, and other figures.

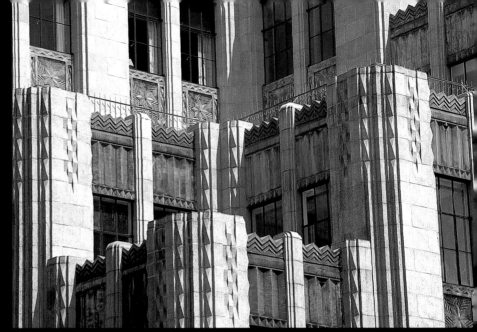

above and top right
Gladding, McBean & Co., Lincoln
Terra-cotta cladding (1,212.5 tons)
on Bullocks-Wilshire department
store (now Southwestern University
School of Law). Los Angeles.
John and Donald Parkinson.
Feil and Paradice. Jock Peters.
architects. 1928.

right
Gladding, McBean & Co., Tropico
Glazed terra-cotta cladding
(978 tons) on Eastern Columbia
Building (now 849 Building).
Los Angeles. Claude Beelman.
architect. 1929.

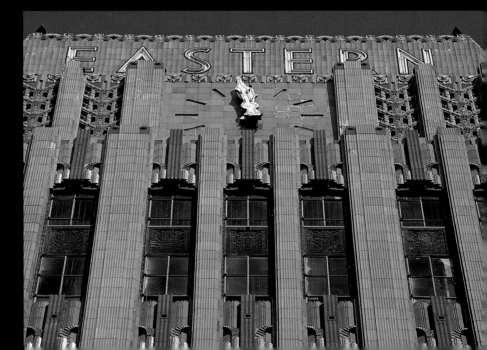

The first big break in pottery design in California came from an unlikely source: New York City. The San Diego promoters of the 1915 Panama-California International Exposition hired New York architect Bertram Goodhue to design the buildings for the Balboa Park site.[3] Although the impressive assemblage of structures he and his staff created was a mixture of styles, Spanish elements ruled. Not only was the entrance bridge across Cabrillo Canyon[4] to the exposition site on Viscaino Mesa[5] designed after the Alcantara bridge in Toledo, Spain, but the tiles used to ornament several of the exposition's buildings were modeled after geometric designs familiar from Granada's thirteenth-century wonder, the Alhambra. These designs had been introduced into Spain by the Moors, Muslims who came from North Africa in the eighth century and, during their seven-hundred-year occupation of much of the Iberian Peninsula, greatly influenced architecture and decorative arts in Spain.

Many of the tiles made for the exposition were produced by California China Products of National City and other San Diego–area potteries. The Hispano-Moresque style, with rich opaque glazes so unlike the restrained, translucent Arts and Crafts glazes, soon influenced tile manufacture throughout the state. In 1916, Fred H. Wilde of California Clay Products Co. moved to Arequipa Pottery, bringing the new style to Northern California, and in 1927 the Hispano-Moresque Tile Company—need I say more?—opened in Los Angeles.

The great post–World War I construction boom, combined with a craze for Spanish Colonial Revival architecture and decorative arts, was a boon for tilemakers. Numerous new California companies joined the already established ones in making tile not only to accent Spanish Colonial homes and civic buildings,

top
California China Products Co., National City
Tiles by suppliers to San Diego's 1915 Panama-California International Exposition. c. 1915.

above
Claycraft Potteries, Los Angeles
Tiles for the Pantages Theater. Hollywood. c. 1929.

Catalina Pottery, Avalon
Tortilla server (c. 1930), and tiles
(c. 1928) in Monterey Furniture bar.

below
California Faience, Berkeley
Bookend tile. hammered
copper frame. and lamp.
Dirk van Erp. 1920s.

Arequipa Pottery, Fairfax
Vase. c. 1915.

but also as a practical adjunct to furniture. Tiles provided attractive and durable surfaces for wood and metal-framed side tables, as well as dressers, bars, and sideboards. Many of the latter were part of the Monterey furniture line manufactured by Mason Manufacturing for Barker Bros. of Los Angeles beginning in 1929. George Mason's reinterpretation of the furnishings associated with the Spanish colonial city of Monterey (which became the first capital of the Mexican province of Alta California in 1822) integrated metal strapping and coarse rope, as well as tile, into their construction. On a small scale, Mason was the Ralph Lauren of his day.

Although by the 1920s many of the California Missions were decrepit, idealized images of them were a favorite on individual decorative tiles and multitile tabletops. Missions adorn the tiles of many companies, including Walrich Pottery of Berkeley; Taylor Tilery of Santa Monica;[6] California Faience of Berkeley—known for its Spanish galleons and other pictorials in unmistakable, luminous glazes; Batchelder of Los Angeles; CALCO of South Gate; and Claycraft of Los Angeles. During the dour mission era itself, however, the tiles in and around the California missions were plain terra-cotta floor pavers; decorations were painted directly onto stucco walls and wood surfaces.

California Clay Products Co., or CALCO, located in South Gate, near Los Angeles, from 1923 to 1933, was among the many distinguished tile companies in Southern California. Although it produced excellent tiles in the Arts and Crafts, Hispano-Moresque, and Mayan Revival styles, it is perhaps best remembered because its founder, Rufus Keeler, left his company in 1926 to build the new Malibu Potteries, which in its six years of operation would become one of California's most creative tileries and whose work is, as we shall see, among the most accessible.

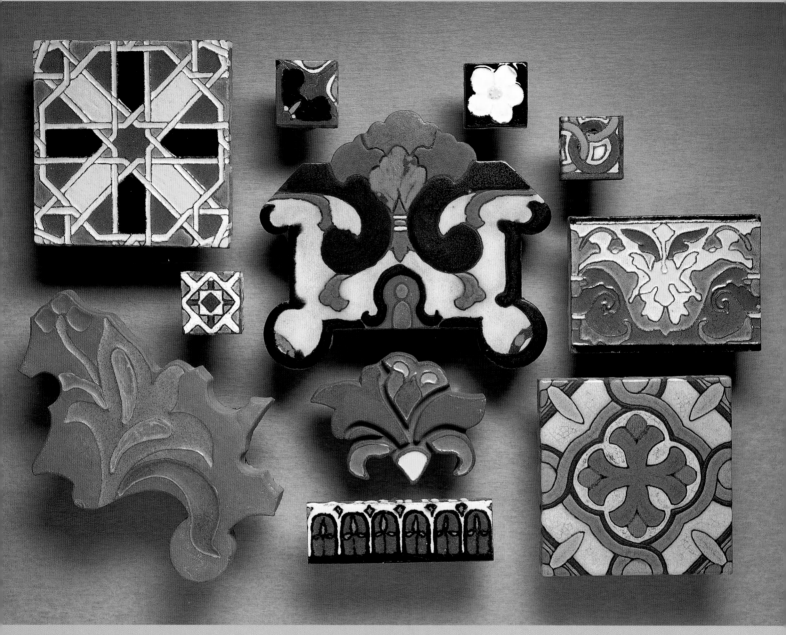

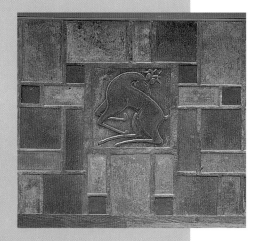

Malibu Potteries, Malibu

Hearth (detail). 1927–1928.
Incised and gloss-glazed central
tile surrounded by matte-glazed
field tiles. c. 1927. Los Angeles
residence.

Malibu Potteries, Malibu

Tiles. 1926–1932.

The true story of the founder of the Malibu Potteries may seem as apocryphal as any of the fantasy myths of California. In 1887, Rhoda Mae Knight, a young schoolteacher from Trenton, Michigan, married Frederick Hastings Rindge, a young man of means from Cambridge, Massachusetts. Five years later Frederick bought the "Rancho Topanga Malibu Simi Sequit," which extended twenty miles along the California coast from Santa Monica to Oxnard, including what we now call Malibu. Around the turn of the century the state supreme court ruled that, in spite of the Rindges' objections, a coastal railroad should be built through their property to connect Los Angeles and San Francisco. To keep outsiders from invading their lands the Rindges said, in effect, "You want a railroad, we'll build you a railroad." Shortly after they incorporated the Hueneme, Malibu, and Port Los Angeles Railroad, Frederick died, making Mae the world's first female railroad president. In 1926, after expenditures on the railroad and legal fees protecting her property had taken a precipitous toll on her finances, Mae Rindge founded the Malibu Potteries at Surfrider Beach. With Rufus Keeler's remarkable glazes, it was providing tile for residential construction by 1927.[7]

The Adamson House, built near the pottery by Mae Rindge's daughter and son-in-law and now open to the public,[8] offers an unparalleled opportunity to see, in extremis, how tiles were and can still be used in homes. Its patios are covered with terra-cotta pavers bearing bas-relief geometric designs and pictorial imagery, like the leaping stag found both on the upstairs patio of the Adamson House and in the hearth of a 1927 Los Angeles residence. You might not want your kitchen floors, counters, and walls covered in half a dozen colors, as the Adamson House's kitchen is, but that installation is nonetheless an astonishing work of inventive excess. After the Malibu Potteries closed in 1932, one of its designers,

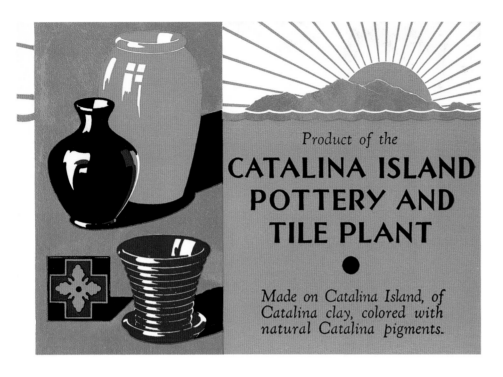

Product of the
CATALINA ISLAND POTTERY AND TILE PLANT

●

Made on Catalina Island, of Catalina clay, colored with natural Catalina pigments.

Bill Handley, went to work at the Taylor Tilery in Santa Monica, which may account for some Taylor tiles being almost indistinguishable from certain Malibu products.

In 1919, William Wrigley—"The Chewing Gum King" and owner of the Chicago Cubs—bought Santa Catalina Island, which on a clear day can be seen off the shore of Malibu. Wrigley, who was developing the island as a resort, established the Catalina Clay Products Company in 1925 to provide his construction projects with a convenient and inexpensive supply of bricks made from the island's red clay. By 1927, the Catalina Pottery began making decorative paving tiles for patios and entranceways. As with traditional plain Mexican terra-cotta floor and patio pavers, the matte red clay was prominent, but in the Catalina Pottery versions uniformity was relieved by geometric decorations in rich, high-

Footnotes

1 Hazel V. Bray, *The Potter's Art in California* (Oakland: The Oakland Museum, 1980), p. 17.

2 Robert Winter, *Batchelder: Tilemaker* (Los Angeles: Balcony Press, 1999).

3 San Diego staged the exposition to bolster the economy of the city, which expected to be the first American port of call on the Pacific Coast for ships passing through the just opened Panama Canal.

4 Juan Rodríguez Cabrillo, a Portuguese navigator sailing under the flag of Spain, explored the California coast in the 1540s.

5 Sebastián Vizcaíno explored the California coast in 1602.

6 Among Taylor's employees in 1938 was Simon Rodia, creator of the Watts Towers. Norman Karlson, *American Art Tile* (New York: Rizzoli, 1998), p. 176.

7 Keeler died at age 49 after inhaling cyanide fumes from one of his glaze recipes.

8 Adamson House and Little Malibu Museum, 23200 Pacific Coast Highway, Malibu, California, 310/456-8432.

9 The Catalina tiles that ornamented the Catalina swimming pool since 1930 were replaced in 1990 with unrelated modern ones. *See* Larry Harris, *The Jewels of Avalon: Decorative Tiles of Catalina Island* (San Marcos, California: Lawrence Harris, Jr., 1999), p. 52.

gloss Hispano-Moresque glazes with the added inspiration of a Mexican palette: orange, cobalt, green, yellow, and black. Not long after these tiles started to be made the same glazes would brighten up solid-color pottery dinnerware, vases, and gardenware.

Catalina tiles were used on furniture and on buildings as far from the island as the Arizona Biltmore Hotel in Phoenix.[9] The Catalina tiles in the town of Avalon on Catalina Island provide the most concentrated public exposition of California Pottery anywhere. From storefronts facing Avalon Harbor on Crescent Street to pavers on the entry to the Inn at Mt. Ida (formerly the Wrigley Mansion) and the entrance path at the current Wrigley home, they can be seen by visitors at any time.

Although tiles continued to be made by numerous companies in Northern and Southern California well into the 1930s, at the end of the 1920s their star was eclipsed by a ceramic solar flare that they themselves had inspired. Until then many potteries concentrated on agricultural stoneware and terra-cotta bricks, vases, pipes, and plain roofing tiles; in the 1920s a sign on the J. A. Bauer Pottery Company plant proclaimed: "Stoneware, Lawn Vases, Flower Pots." Some of those companies, including Bauer, Pacific Clay Products, and Metlox Potteries in and near Los Angeles, and Garden City Pottery in San Jose, would play pivotal roles in the craze for solid-color pottery that soon swept the country.

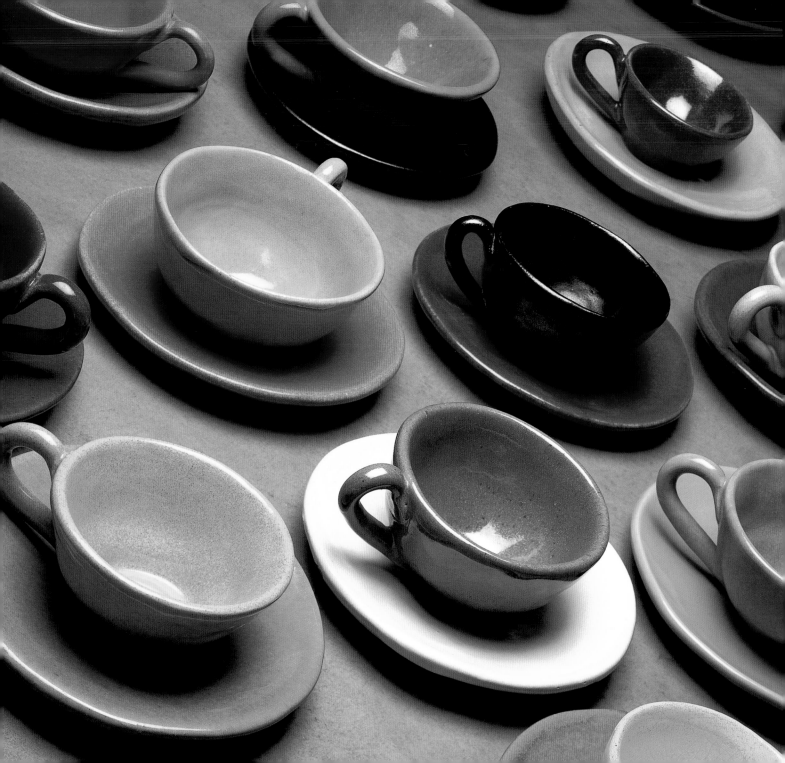

Chapter 2 : COLOR CRAZED

It's 1930. Your good dinnerware is French or English, white decorated with an elaborate floral or geometric pattern, and your everyday dishes are cheaper American imitations of the European imports. On your travels in the Southwest you've seen Mexican peasant pottery with multicolored images on solid-color backgrounds, pottery that you're afraid is too humble to use (and, we now know, also too lead-laden), but that looks good on walls and in hutches. Then, while driving along the Pacific Coast Highway, you stop at Durlin Brayton's pottery stand in the California artists' colony of Laguna Beach, and for the first time you see dinnerware in pure solid colors—colors you may never have seen anywhere before, much less under the food on your table: chrome yellow, eggplant, fuchsia, turquoise, metallic black. Maybe, if it didn't strike you as just too weird, you'd sense that the look of this American pottery, with its interplay of simple clay forms and luminous glazes, was sophisticated enough to go with your Arts and Crafts–style furniture yet inexpensive and practical enough to be used out-of-doors. You might even take some home with you.

Whether you did or didn't buy any of Durlin Brayton's pottery, you'd still have been present at the beginning of another American revolution.

For until the early 1930s, American taste in dinnerware and decorative ceramics had been in the thrall of the "generally held American prejudice for European porcelains and china."[1] Working-class and farm families who couldn't afford the cheaper American-made imitations of European imports had to make do with rustic white stoneware and yellowware (yellow-tinted stoneware). A timid American revolt against Old World cultural hegemony had taken place in 1923, when the Sebring Pottery Company of Sebring, Ohio, broke the rules by being the first producer of popular-priced dishware to change the standard under-the-decoration color from white to ivory, a move whose daring is probably impossible for us to comprehend today.

Then, at the start of the 1930s, solid colors from California's potteries burst into American homes like fireworks. Much like Depression glass, this colored kitchenware, dishware, and gardenware allowed masses of Americans who were affected by the dreary economy to enjoy what looked like handmade luxury at affordable prices. But unlike Depression glass, which imitated already old-fashioned designs, California's potteries offered innovation and modernity along with good value. Appearing as they did at the beginning of the long economic and social dislocation, these optimistic and accessible goods seemed to say: "If you can't be happy, at least be cheerful."

In the 1920s, primary colors were already being used in cutting-edge paintings and painted ceramic designs in England, Germany, and Czechoslovakia. But the use of solid color as decoration on household pottery and gardenware was an American design contribution: As Susan E. Pickel notes: "The potteries of California were pioneers in the development of solid-color glazed tableware and kitchenware."[2] In subsequent chapters we will show some of California Pottery's brightest moments.

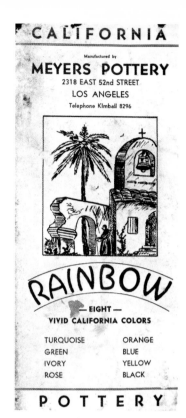

above
Meyers Pottery, Vernon
California Rainbow brochure cover. c. 1935.

right
J. A. Bauer Pottery Co., Los Angeles
Ringware plates: shapes by Louis Ipsen. glazes by Victor Hauser. c. 1932.

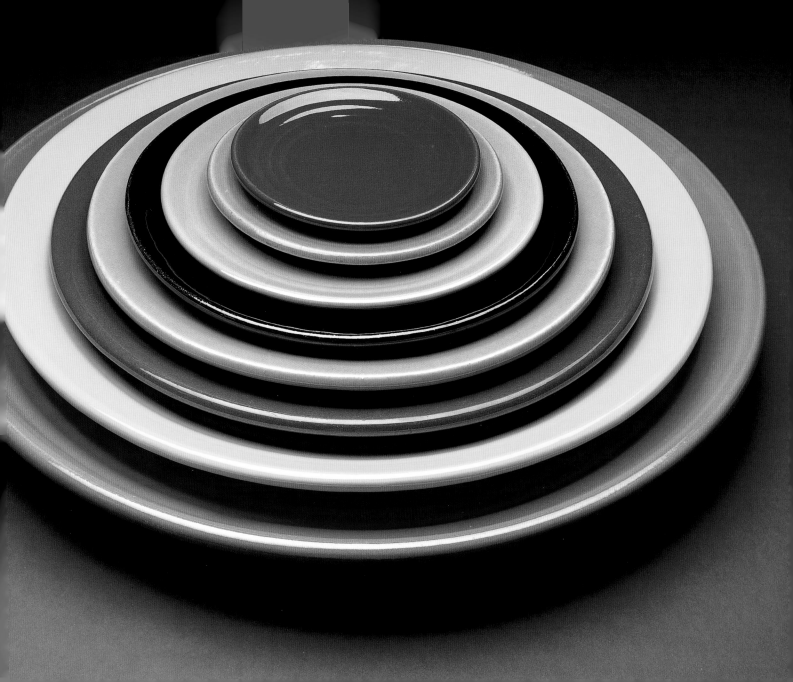

There had been some experimentation with solid colors in the eastern United States in the twenties, notably "Fayence," tried out by Fulper of Trenton, New Jersey, in three colors, and Stangl's green Colonial line, but it took a combination of California color sense and California technology to make underglaze colors commercially viable. The production of durable pottery in the colors usually associated with California Pottery—green, orange, yellow, and cobalt blue—as well as burgundy, "delph" (delphinium), and black, was made possible by a California discovery. The blending of talc, a fine-grained, locally plentiful mineral, with other ores allowed California potteries to produce a body that bound with solid-color glazes and made them almost as vitreous and craze-resistant as actual china.[3] Previously, colors applied to clay were either blended in or painted on the surface and then covered with a clear glaze, neither technique producing the intense, uniform, and durable coloring required for large-scale production.

Colored pottery was a logical consequence of the bridging of interior and exterior landscapes fostered by the Spanish Colonial Revival. Californians needed little encouragement to serve meals outdoors on the new, easily replaceable, colored dishware that comfortably hobnobbed with urns and flowerpots in the very same glazes. In other, less clement, parts of the country, California Pottery's untamed colors, plus its informal shapes and rustic weight, surely conjured images of year-round outdoor dining on the patio and made it seem as

Garden City Pottery, San Jose
Oil jars. c. 1936.

if this pottery had come straight from the cupboards of a gracious Spanish Colonial hacienda.

By making colored pottery accessible to almost everyone, California potteries were bringing one of the latest developments in the decorative arts to the general public; it was a sort of pottery populism. Yet the voguish "peasant" colors of California Pottery also appealed to wealthy Americans, though they would use it only for informal breakfasts and lunches, reserving imported china for dinners and special occasions.

It isn't known for sure which California pottery deserves the we-did-it-first honors for this innovation, for at about the same time that Durlin Brayton (1898–1951) began making his semi-handcrafted colored pottery, Victor Hauser, a twenty-three-year-old ceramic engineer newly arrived in California from Illinois, was creating three solid colors for J. A. Bauer's utility wares—objects like mixing bowls, intended only for food preparation or storage.

In about 1930, those colors—orange, yellow, and green—along with several others came out of the kitchen and into the dining room. From Bauer's catalogs we learn that this "California Colored Pottery" was available in vases, urns, and oil jars, along with the company's first colored dinnerware, commonly called "plainware."[4] Unlike the company's subsequent, enormously successful "ringware," it lacked an in-mold pattern of raised rings. Both the plainware and the ringware were designed by Louis Ipsen, who, like Victor Hauser, had come to Los Angeles from Illinois.

Perhaps, as *California—Magazine of Pacific Business*, asserts in its September 1937 issue, this all began when Bauer "decided to add some color to their lines" in 1927.[5] Or when Catalina Clay Products began making colored pottery for tourists. What is known is that Bauer was the first large-scale producer

and distributor of California colored pottery, and that by 1930, Brayton-Laguna, Bauer, and Catalina were all making it. Metlox Potteries would follow in 1932 with its "100" series—marked quite simply "California Pottery"—and in 1935 Vernon Kilns would introduce its Montecito dinnerware, which was soon renamed Early California. The new solid-color glazes were so successful that California potteries were soon applying them to all manner of objects: umbrella stands, muffin servers, bookends, dog and cat dishes, honey pots, pipe rests, cigarette boxes, sand jars, candleholders, beer steins, birdbaths, vases, even pottery buttons.

Each of the Big Five pottery producers in Southern California—that's what Bauer; Pacific Pottery; Metlox; Gladding, McBean/Franciscan; and Vernon Kilns cleverly called themselves to jointly promote their colored pottery—and Garden City in Northern California created its own distinctive glazes. But Durlin Brayton, a graduate of Hollywood High School who had studied at the Art Institute of Chicago, created an unequaled variety of colors for his pottery. On his press-molded dinnerware—the clay was hand-pressed into molds—he applied glazes, many of which seem to be illuminated by a light from within rather than from a coating on the clay's surface.

Color is what gives visual strength to J. A. Bauer's pottery, since its shapes are mostly adaptations of familiar forms. Unlike Brayton-Laguna's glazes, those used by Bauer and the other more automated pottery producers were opaque, creating a less nuanced but more dramatic effect. Perhaps the most dramatic use of Bauer's colors is on its stacking refrigerator set, which permits up to four colors (three containers and one lid) to play off one another in one rainbow unit. Bauer Pottery's solid-color ringware, which found its way into households

J. A. Bauer Pottery Co., Los Angeles
Refrigerator leftover stack. c. 1932.

Garden City Pottery, San Jose
Flower frogs. c. 1936.

From Colorful California

**VIVID, ARRESTING POTTERY IN
SMART DINNER AND BUFFET SERVICES**

In the rich, warm colors reminiscent of old Spain...yet styled to the modern mood...Pacific pottery brings the *fiesta* spirit to present day dining.

Whether it appears as the first cheerful note on the breakfast tray...as part of the color harmony of an informal lunch...a zestful background for buffet suppers...or even as a gala touch to more formal dinners...there's a subtle magic about these decorative pieces.

Pacific pottery is satin-smooth in texture. Heat and cold resistant. Designed for every serving need, at prices surprisingly moderate. Six appealing colors, Apache Red, Lemon Yellow, Delphinium Blue, Jade Green, Sierra White, Pacific Blue.

Sold at leading stores....Descriptive folder in colors available upon request

Pacific **POTTERY**

Division of PACIFIC CLAY PRODUCTS, Los Angeles, California

Pacific Pottery, Los Angeles
Hostessware advertisement.
House & Garden magazine.
April 1935.

across the country, into numerous magazines, and even into a few movies, was the first widely collected California pottery.

In 1932 or 1933, after having adorned some of its yellowware in various blends of colored glazes created by Harold Johnson and some of its white stoneware with single colors, Pacific Pottery released its ninety-piece solid-color Hostessware line.[6] By April 1935 Hostessware was available in Pacific blue, jade green, Apache red, lemon yellow, Sierra white, and delphinium blue. Company advertisements showed mixed place settings in two to all six colors.

In Northern California the principal producer of colored pottery was Garden City Pottery in San Jose, "the Garden City." Prior to the publication in 1999 of the *Guide to Garden City Pottery* by Jim Pasquali, hardly anything was known about this company, which made colored pottery from 1935 until about 1950. Now, not only do we know who was responsible for its designs, but we can see what a significant body of work Garden City produced.[7] Moreover, since none of its colored ware was marked in any way, unlike its ink-stamped stoneware, Garden City pottery was for a long time—and still often is—misidentified by sellers and ignored by buyers, who didn't feel comfortable acquiring what seemed to be "generic" pottery.

There is, in fact, nothing at all generic about Garden City's pottery. Not only does the inventiveness of its shapes, designed by Royal Arden Hickman, rival that of the company's Southern California counterparts, but the glazes, created by veteran ceramic engineer Paul Gifford Larkin in collaboration with neophyte

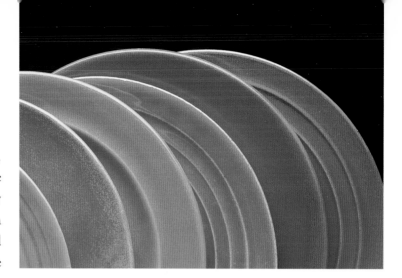

Merrill Cowman, are unmistakable. Larkin, who had previously been in charge of glaze development at Gladding, McBean & Company in Lincoln, and then at Pacific Clay Products in Los Angeles, came to the thirty-year-old Garden City Pottery in 1934. Previously, like most of its peers in Southern California, the company had made white stoneware crockery, sewer pipe, and terra-cotta florist wares. By 1950 Garden City Pottery had stopped making most of its colored wares and was once again concentrating on garden products.

Of all the California potteries that produced solid-color dinnerware, only one, Vernon Kilns, had previously made full lines of dinnerware. Its standard lines were white with various decal decorations. Although Vernon Kilns would go on to make major contributions to California Pottery, it didn't start using solid colors until about 1934 and introduced its full line of Early California only in 1935. Vernon was, however, one of the first companies, after Metlox Potteries and Gladding, McBean & Company, to use pastel glazes on both on its Modern California dinnerware and on its artwares.

Without going as far as decoration, Winfield Pottery of Pasadena took the use of color one step beyond solid colors by adding a second color to both dinnerware and vases. The impression that those extra colors were hand-dipped added to the handcrafted "feel" of the company's matte glazes. The almost square plates and bowls, introduced in 1937, were the work of Margaret Mears Gabriel, who had recently joined the company and who, with her husband, Arthur, became the owner of Winfield in 1939. But as attractive as the company's colored pottery may be, Winfield would subsequently become best known for its decorated dinnerware.

Footnotes

1 Hazel V. Bray, *The Potter's Art in California* (Oakland, The Oakland Museum, 1980), pp. 1–2.

2 Susan E. Pickles, *From Kiln to Kitchen: American Ceramic Design in Tableware* (Springfield: Illinois State Museum, 1980).

3 *California—Magazine of Pacific Business*, September 1937, p. 18, attributes this innovation to "the ceramic engineers of Gladding, McBean & Co." Though Willis O. Prouty, who would found Metlox Potteries in 1927, had patented a talc body in 1920, the patent was later acquired by Gladding, McBean.

4 Although the vases, candle-holders and other forms created by Matt Carlton for J. A. Bauer were hand-thrown and not molded, many were stock items turned out in large numbers.

5 *Magazine of Pacific Business*, September 1937, p. 19.

6 Pacific Pottery, Price List, February 1, 1934.

The marketing of colored pottery by the Big Five was astute. Playing on the established appeal of "California" as both myth and real destination, they gave their products evocative names: El Patio (Gladding, McBean & Company, 1934); Poppy Trail (Metlox Potteries, 1934), Early California (Vernon Kilns, 1935). In 1936 Gladding, McBean & Company named its entire dinnerware and art pottery division "Franciscan," after California's early missionaries, the Franciscan padres, and later included the image of a mission on its label. All of these trade names were designed to evoke the mythic California of Spanish-colonial days and travel posters.

It's not surprising, of course, that the success of Bauer's ringware and Pacific Pottery's aggressive nationwide marketing of its Hostessware—in *American Home, House & Garden,* and other shelter magazines—inspired imitations, and competition. Although Japan usually comes to mind when we think of knockoffs of American (and European) designs in the 1930s—and at least one imitation of colored California Pottery was made there in the thirties—at that time the imitators of colored pottery were overwhelmingly American. Padre, Tudor Potteries' Hollywoodware, and Meyers Pottery's California Rainbow were knockoffs made right in Los Angeles.[8] Lu-Ray Pastels by Taylor, Smith & Taylor in Chester, West Virginia, and Yorktown by Edwin M. Knowles in East Liverpool, Ohio, were eastern imitators.

The most obvious imitation of colored California Pottery, and far and away the most successful, was, of course, marketed by Homer Laughlin of Newell, West Virginia, under that now famous, faux-*Californio* name, Fiesta. Up

to the 1930s, the annual Fiesta de Los Angeles—a "tradition" started in 1894 as a way to attract tourists by celebrating the city's colorful Hispanic heritage—was an important civic event in the state. That the word "fiesta" was not yet American when colored California Pottery had already achieved national reach, is demonstrated

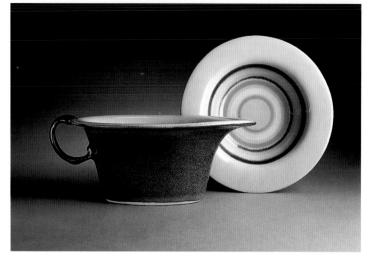

by a Pacific Clay Products advertisement in *House & Garden* magazine in 1935 (a year before the introduction of Fiesta dinnerware). It boasts: "From colorful California . . . Pacific Pottery brings the *fiesta* spirit to present day dining." (Fiesta was released in 1936, and after being out of production for several years is now once again being made in West Virginia.)

After pastel-colored dinnerware and accessories were added to California's colored pottery production—on Metlox Potteries' Poppy Trail in 1934 and its Mission Bell in 1935; on Gladding, McBean's Coronado in 1936; and Vernon Kilns' Modern California in 1937—Taylor, Smith & Taylor of Chester, West Virginia, released its Lu-Ray Pastels in 1938. The appeal of California-made colored pottery, whether in pastels or saturated colors, was such that in spite of vigorous competition and "prices slightly higher in the East" it was popular enough to remain in production for quite a long time: Vernon Kilns' Early California for more than fifteen years; Gladding, McBean's El Patio and Coronado for twenty years; and Bauer's ringware for twenty-five years.

7 *The Guide to Garden City Pottery* (Campbell, California: Adelmore Press, 1999).

8 Padre (1934–1943) was located in the Lincoln Park district of Los Angeles, not far from the Bauer and Pacific potteries.

Chapter 3 : WIT and WHIMSY

Pacific Pottery, Los Angeles

Cocktail mixer (left) c. 1934. Though tall and handsome. it isn't especially sure-footed. but it cost about one-half the price of the remarkably similar. and better balanced. chrome cocktail mixer designed by Walter von Nessen for Chase Brass & Copper Co. c. 1934.

A photograph taken many years ago at the Gladding, McBean & Company plant in Lincoln, California, shows cupids riding on turtles, waiting their turn to perch on one of the many buildings the company clad in its monumental, ornamental terra-cotta. And among the innumerable figurines made by California potteries—but not the subject of this book—surely one of the most entertaining is the Shotgun Wedding group designed by Andy Anderson in the 1930s for Brayton-Laguna Pottery: girl, boy, toddler, mother, father—holding shotgun—and preacher.

But figures are far from being the only witty inspirations to be encountered in California Pottery's long history. At the beginning of the 1930s, when potteries that had been making utilitarian kitchen, agricultural, and florists' pottery decided to make dinnerware,[1] they had to come up with dozens of designs for everything from cups to casseroles to ashtrays to cigarette boxes, which were part of dinnerware services in those days. It took a fair amount of California's unbridled imagination and more than a little wit to accomplish this quickly. And it didn't seem to matter what material these forms had originally been made in—

lava stone, wood, enameled tin, even chrome—California potteries could, and did, manufacture them in clay.

In order to compete with established dinnerware producers in the East and Midwest, and with each other, each California company had to offer its own distinctive shapes. Considering the results, it would seem that in keeping with California's reputation, "Anything Goes" could have been their common slogan. Some of the hundreds of shapes they produced were original, some were adaptations of existing forms, some were traditional, others modern, some were perfectly functional, others were patently impractical. But all would be mass-produced for use in the homes of Americans throughout the country.

Durlin Brayton used more than a dozen shapes for the semi-handcrafted dinnerware he began producing in Laguna Beach by 1930. The pitchers and teapots, with their radically raised handles, appear to be original designs, but his oval bowl is doubtlessly a witty translation into clay of a shape originally made in another medium. Both its concave form and its uneven surface—the clay was hand-pressed into a mold—make this piece look like a traditional hollowed-out Latin American wooden vessel in a bright, Mexican color.[2]

J. A. Bauer's popular ringware was based almost exclusively on nine-teenth century shapes familiar to most Americans at the time. Yet its in-mold rings and colors allowed Bauer to integrate into its dinnerware line, and California-ize, such "new" shapes as the traditional Mexican water jug. This handsome vessel, practical for bedside use even after running water was introduced into homes, kept water clean and especially handy because its tumbler, when inverted, doubled as a lid. Bauer's version, though also quite handsome, is not as practical as the traditional jug since its waferlike lid doesn't extend far

top right
Catalina Pottery, Avalon
Faceted tumblers and pitcher, c. 1930, were copies of American glass versions popular in the late nineteenth and early twentieth centuries, which themselves were copies of an eighteenth-century Georgian silver shape.

bottom right
Brayton-Laguna Pottery, Laguna Beach
Oval bowls by Durlin Brayton, c. 1930, echo the traditional wooden *guacal* of Mexico and Central America.

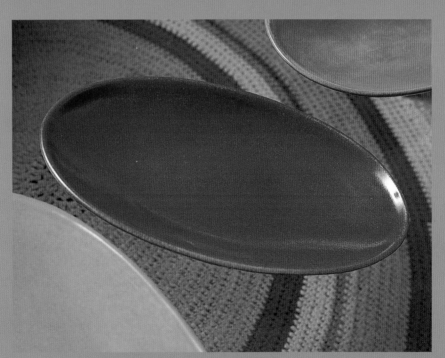

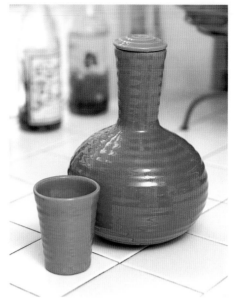

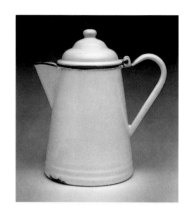

enough into the neck to ensure that it stays in place. Because it was easily lost or broken, this $2^1/2$-inch disk has become highly sought after by collectors.

Catalina Pottery also found inspiration in Mexican forms. Catalina's tortilla server with its "carved" lid, is based on a traditional wooden or stone form, and the base of its shrimp cocktail server is a slight reworking of the Mexican *molcajete*—the lava-stone vessel in which corn, chilies, seeds, and other foodstuffs were traditionally ground with a mortar. Both of these vessels represent milestones in American culinary habits, showing as they do that both the tortilla and the shrimp cocktail were already part of the American diet, at least in California.

Unlike Bauer's more homogeneous ringware, Pacific Pottery's Hostessware set consisted of designs from sources as diverse as traditional American, classic Japanese, and up-to-the minute modern.[3] All of these disparate styles, and others, were integrated, more or less successfully, by their shared colored glazes and by a series of in-mold rings that bear a strong resemblance to those found on traditional American graniteware.[4]

Pacific Pottery, Los Angeles

Hostessware waffle batter pitcher (left), maple syrup pitcher, and tray. c. 1934.

Footnotes

1 Only Vernon Kilns' predecessor Poxon China was a dinnerware manufacturer in the twenties. In the late twenties Bauer had made one limited yellowware service before it introduced its colored dishes.

2 The production of Brayton-Laguna dinnerware was made by more than one hand—not just by Durlin Brayton himself—as witnessed by a console bowl that bears the hand-incised mark "Brayton-Laguna Pottary" as opposed to the usual "Brayton-Laguna Pottery."(see page 108)

Part of Pacific Pottery's Hostessware service was a pair of lidded pitchers, which company advertising shows on a rectangular pottery tray. The fat pitcher is identified as being for waffle batter while the long-spouted one was to be used for maple syrup, for which it seems apt, as the feet would keep sticky syrup drips off tabletops. (But I wonder how many depression-era housewives felt that they had to have, or for that matter could afford, a dedicated waffle set?)

But not all California pottery experiments were practical. In addition to the ergonomic Streamline shapes used for its Modern California line, Vernon Kilns created the dramatic Ultra shape.[5] In spite of its streamlined beauty, Ultra, with its svelte inverted handles, seems to have been intended to subvert Mies van der Rohe's famed dictum "form follows function" (see page 72). There is a reason why hollowware pieces like beer steins—and cups, pitchers, and teapots—normally have a place for your thumb: balance. Even though the Ultra teapot is arguably very beautiful, if you pick it up when it's filled with hot tea you'd better wear heat-proof shoes: without a perch for your thumb on the handle, the pot's spout inevitably pulls downward. When Elsa Rady, the celebrated contemporary

Metlox Potteries, Manhattan Beach

Candleholders. c. 1940.
Although their function may not
be immediately obvious, these
candleholders are practical.

3 Who designed this wealth of
shapes is not known. It's been
said that it was Melvin Lattie,
Pacific's sales manager from 1932
to 1938, but his son, James Lattie,
discounts this possibility.
Conversation with the author,
April 12, 2000.

4 The resemblance is far stronger
to graniteware than to Bauer's
ringware, to which that aspect
of Hostessware's design has fre-
quently been compared.

5 So-called because Vernon first
used it for its solid-color Ultra
California pattern. The company
name may have been either
Wilshire or Sierra, two otherwise
unidentified patterns credited to
Vernon in the 1936 *China &
Glass Trade Directory* (Pittsburgh:
China, Glass, & Lamps, 1936).

6 Conversation with the author,
April 3, 2000.

ceramist who was part of the design team at Franciscan in the late 1960s, saw the
Ultra shape she exclaimed: "I can't imagine something so nonfunctional getting
through the design approval process!"[6] Fortunately it functions well on a shelf.

It has been said that Rockwell Kent, who created three series of illus-
trations for the Ultra shape, was furious because its design problem caused
numerous returns from buyers who found some of it unusable. Then there are
the questionable Calas vases by May and Vieve Hamilton: graceful but gravity-
defying, they are almost always found chipped, a testimony to their propensity
to fall over even when they don't have flowers in them.

Perhaps it was inevitable that the land of the automobile would be on
firmer ground with aerodynamic shapes. As we shall see, California's potteries
successfully incorporated the design principles of Streamline Moderne and other
popular thirties styles into their products.

Vernon Kilns, Vernon
"Architectural" candleholders
by Jane Bennison. c. 1936.

Chapter 4 : STREAMLINE, DECO, ZIGZAG

The mid-1920s to the late 1930s was a period of unparalleled creativity in the decorative arts, particularly in ceramics. During that time England, France, Czechoslovakia, Holland, Japan, and Germany—until the antimodern Nazi Party took control in 1933—were leaders in the production of shapes and decorations in Streamline, Zigzag Moderne, and Art Deco. In the United States in the 1930s, modern ceramics were being created by American-born designers, along with Europeans who had sought refuge from the turmoil in their own countries.

In California, with its potteries flourishing and in immediate need of new shapes, these modern developments couldn't have come at a better time. In Los Angeles, Pacific Pottery had never, as far as is known, made a dining room dish in its life, yet in about 1932 it was faced with designing close to a hundred pieces of pottery for Hostessware, its first set of tableware and accessories. Pacific jump-started the design process by adapting shapes from all over—footed bowls from Mexico, a teapot from Japan, rectangular trays from Europe, and pitchers from nineteenth-century America.

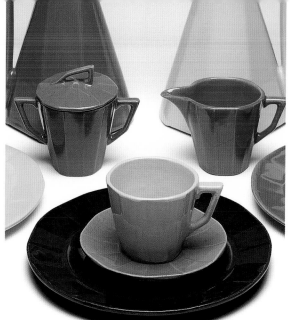

Despite Hostessware's hodgepodge of styles, united only by its in-mold rings and characteristic glazes, the line contains some outstanding pieces of design. Perhaps the most striking is the tall after-dinner coffeepot whose gracefully proportioned body looks like a torpedo standing on end delicately balanced by its sweeping spout and handle. Other outstanding Art Deco designs are to be found molded into Pacific Pottery's sand jars. Used principally in the lobbies of movie theaters and office buildings, these tall cylinders were filled with sand in which cigarettes were to be extinguished.

As we have already seen, Catalina Pottery was an inventive adapter of traditional forms for its dinnerware. But it also produced some outstanding modern designs. These include an Art Deco tea service whose combination of curves and sharp angles on the teapot, creamer, and sugar bowl seems to have been inspired by chrome examples.

At Garden City Pottery in San Jose, Royal Arden Hickman (1893–1969) transformed the company from a producer of rustic stoneware into a modern innovator. In the 1930s Hickman produced a series of Art Deco vases and at least

above left
Catalina Pottery, Avalon
Trojan pattern. c. 1930.

above right
Garden City Pottery, San Jose
Art Deco dinnerware by Royal Arden Hickman. c. 1934.

right
Garden City Pottery, San Jose
Pillow vases by Royal Arden Hickman. c. 1934.

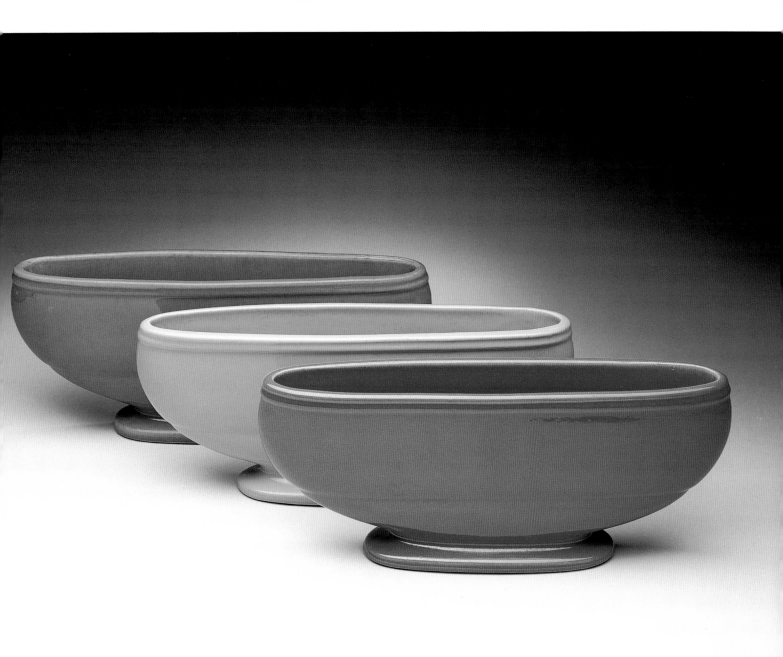

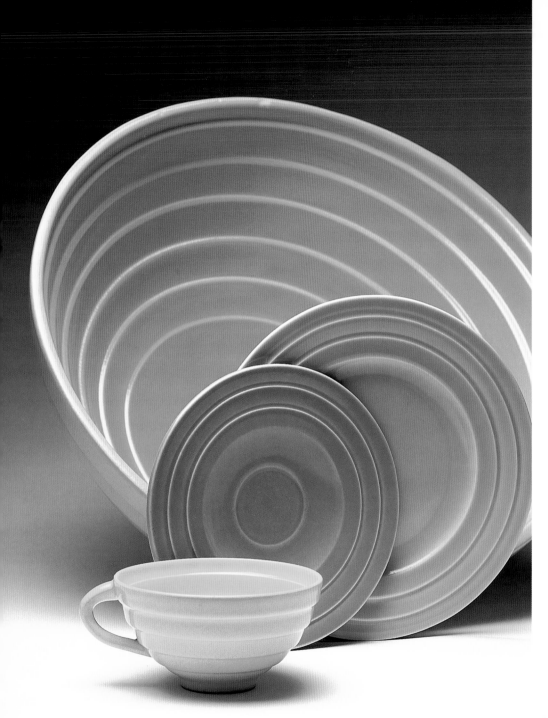

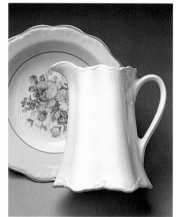
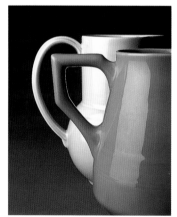

one line of Art Deco dinnerware. Although it is never marked, colored Garden City pottery can often be identified by its distinctive glazes and certain characteristics left by the molds in which some pieces were made. In the absence of extant Garden City catalogs it is not surprising that previously unknown shapes made by the company continue to be identified. After leaving Garden City Pottery in 1939, Hickman had a second career, at Haeger Pottery in Dundee, Illinois, hence the mark "Royal Haeger" on some of their wares.[1]

In 1931, a partnership headed by Faye G. Bennison bought Vernon Pottery, a down-at-the-heels dinnerware company making, like its predecessor, Poxon China, imitation European china, institutional dinnerware, and molded artwares. Vernon Kilns, as the company south of downtown Los Angeles was renamed, continued using traditional shapes for a couple of years. Bennison was an entrepreneur who had previously owned a dry-goods business in Iowa and then was the president of a glass bottle company. With the encouragement of his daughter Jane (b. 1913), who had studied ceramics with Glen Lukens at the University of Southern California, he turned the company around, bringing in modern designers to create new shapes and designs. Gale Turnbull, May and Genevieve Hamilton, and Jane Bennison herself would launch the company into the avant-garde of commercial pottery producers.

Daniel Gale Turnbull (1889–1964) is considered to have been responsible for the crisp yet sensually curvilinear silhouettes of Vernon Kilns' redesigned Montecito shape. The first version used angular handles that were stylized versions of an English dinnerware model whose joints were originally those of bent bamboo, as in the Chinese original from which *they* had been copied. But, as we shall see, Turnbull's most notable contributions at Vernon Kilns would be his decorations, which enlivened much of the company's output toward the end of the 1930s.

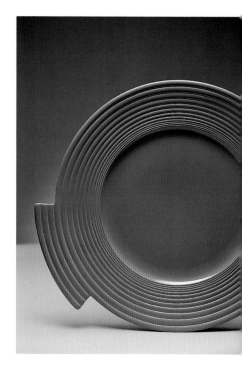

left
Mark: May and Vieve Hamilton
Vernon Kilns. Vernon.

right
Vernon Kilns, Vernon
Cosmic bowl by May and Vieve Hamilton. 1936.

below
Vernon Kilns, Vernon
Rippled platter by May and Vieve Hamilton. 1936.

Of the little national recognition California production ceramics received in the 1930s or 1940s, much of it went to work created by the Hamilton sisters for Vernon Kilns. Several of their decorative and dinnerware pieces were selected for the Fifth National Ceramic Exhibition of 1936 at the Syracuse Museum of Fine Arts, in Syracuse, New York, a show that then traveled to Worcester, Massachusetts; Cleveland, Ohio; Pittsburgh, Pennsylvania; and San Diego, Los Angeles, and San Francisco, California.[2] With some variation this show also traveled to Denmark, Sweden, and Finland in 1937 as part of the Contemporary American Ceramics exhibition, also organized by the Syracuse Museum.[3] Included in the American exhibition was a large salad bowl from the Hamiltons' Art Deco Rhythmic dinnerware service, which looks as if it could have been inspired by the series of architectural vases Keith Murray designed for Wedgwood in England in the early thirties.[4] (For the Scandinavian tour this very large bowl was replaced by a cup, saucer, and plate, perhaps due to shipping concerns.) The Hamiltons' work was also exhibited at the 1939 Golden Gate Exposition in San Francisco.

In addition to their dinnerware lines, the Missouri-born Genevieve Hamilton (1887–1976) and May Hamilton de Causse (1886–1971) produced dozens of vases, figural pieces, and bowls for Vernon Kilns. The in-mold ring decoration of their Rippled dinnerware bears a striking resemblance to that of Fiesta, which was released in the same year, and the drooping handles bring to mind the upside-down handles of Vernon's Ultra shape, which was created at about the same time. The Hamiltons' designs were glazed in many, if not all, of the colors used on Vernon Kilns' Early California, Modern California, and Ultra California dinnerware lines—that is, in about nineteen solid colors. In addition, the Hamiltons used a chrome-yellow glaze that has not been seen on any but their wares.

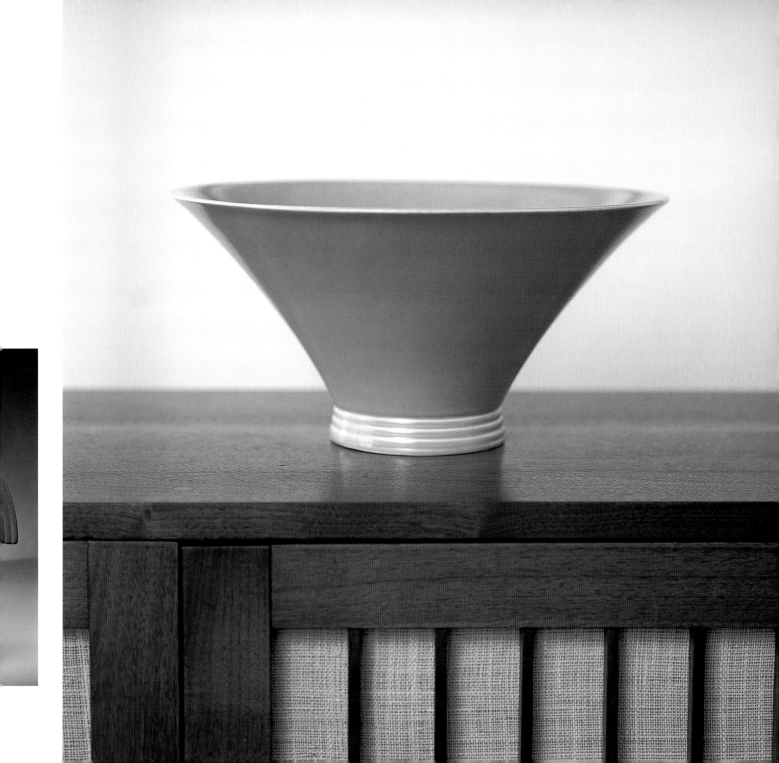

left
Metlox Potteries, Manhattan Beach

Pintoria dinner plates. c. 1936.
A "short set," it contained only
plates, platters, bowls, cups,
saucers, and creamer and
sugar bowl.

right
Franciscan Ware, Los Angeles

(Gladding, McBean & Co.)
Metropolitan teapot, sugar bowl,
and creamer by Morris B.
Sanders, a New York Architect.
c. 1940. This shape was included
in the Fifteenth Exhibition of
Contemporary American
Design at The Metropolitan
Museum of Art, New York, 1939.

Footnotes

1 In 1942, Hickman designed the Melinda shape for Vernon Kilns.

2 *Design*, November 1936, p. 13.

3 Ibid., p. 29.

4 Although attributed in the catalog to Vieve Hamilton, this piece is normally seen with the same inkmark that appears on most of the Hamiltons' designs manufactured by Vernon Kilns.

Jane Bennison worked at her father's company for two years, during which time she had her own imprint: "JANE F. BENNISON VERNON KILNS CALIFORNIA MADE IN U.S.A." About two dozen of her creations were produced by the company, including a set of Art Deco candleholders in architectural forms (see page 56) and more than a dozen bowls intended for flower arrangements. Like the Hamilton sisters' pieces, Bennison's would be made with the company's standard dinnerware glazes. Beyond the nineteen possibilities that permitted, Jane added one of her own, Persian blue, a grayish lavender that is seen only on her shapes.

In 1936, Metlox Potteries issued Pintoria, the company's only departure from the conventional dinnerware shapes it made throughout the 1930s. All the plates, bowls, and saucers of this radical line were rectangular with a round well in the center, producing a striking visual dynamic reminiscent of the Constructivist designs developed in Russia and Germany in the 1920s. (The cups, creamer, and sugar bowl are round; service pieces were not made.) This dinnerware shape had been developed by Jean Tetard in France and was used with great success by Clarice Cliff in England. And although I have been told that its storage advantages may have given it a leg up for use on railroad dining cars, its points chip easily, anywhere.

The outbreak of World War II stifled ceramic design worldwide and virtually ended it for a time in California. The Golden State wouldn't regain its reputation for modern innovation in commercial pottery production until it met Modernism in the 1940s, but between those times it continued to make other contributions to American design.

Chapter 5 : CLAY CANVASES

Thousands of years before the rough fabric we call canvas became the painter's preferred surface, clay was. Painted clay shards and vessels have been found by archeologists on all our planet's inhabited continents. In fact, just a few years ago pottery unearthed in Virginia added greatly to our scanty knowledge of early European settlers in what is now the United States. Although virtually all the painters of early pottery remain anonymous, their designs, whether abstract spatterings or scenes of hunting or myths or battles, were an expression of their time. And whether the decorations on California Pottery were created by unknown craftsmen and craftswomen or by an artist as well known as Rockwell Kent, their work, too, is an expression of their time.

Hardly had the color on their solid-color pottery dried before several California companies began decorating it. Though this was unlikely to have been a reaction to competition from solid-color wares produced in the East—Pacific Clay Products was already decorating its dinnerware in 1934, and the major Eastern competitor, Fiesta, didn't appear until 1936—it was certainly an effort to expand their market. It also played to a well-established tradition. By the early

Pacific Pottery, Los Angeles

Some of the more than two hundred hand-painted decorations on solid-color Hostessware. 1930s.

twentieth century, painting on pottery had long been a popular home-craft and cottage industry in the United States. As Hazel V. Bray points out: "China painting . . . proliferated into a major fad by the [eighteen-] eighties."[1] Well into the 1900s undecorated dinnerware and vases were readily available for this purpose: American firms were importing European blanks and offering them along with "vitrifiable over-glaze colors" and even offered gas- and oil-fueled kilns to fire them in.[2] As much as Americans may have taken to colored pottery, some still wanted pretty pictures.

In the 1920s there were commercial artists who, instead of buying canvases or watercolor paper, bought white stoneware and yellowware from the J. A. Bauer Pottery Co. of Los Angeles and other companies. Whether anonymous or known to us because of their signatures—"Studio of Helen V. Carey, Los Angeles, Calif." for one—they painted directly on stoneware custard cups, on bean pots, and on crocks, on almost any available vessel. And although some of their work is traditional, the spare geometric decorations they sometimes executed might have been a reaction against the elaborate ornamentation of nineteenth century revival and Art Nouveau styles still popular at the time.

Magazine ads show that in 1935, Pacific Pottery of Los Angeles was already decorating its solid-color Hostessware. Although there are no company records to indicate how many different decorations Pacific made, more than two hundred—abstracts, plaids, fruits, birds, firecrackers—have been documented. Who designed the decorations is not known: Contrary to common belief, the initials painted or printed on the bottom of some decorated Pacific pieces identify the pattern, not the artist or decorator.

Of all the California potteries, Vernon Kilns undertook the most ambitious program of decorating its dinnerware and accessories as Faye Bennison,

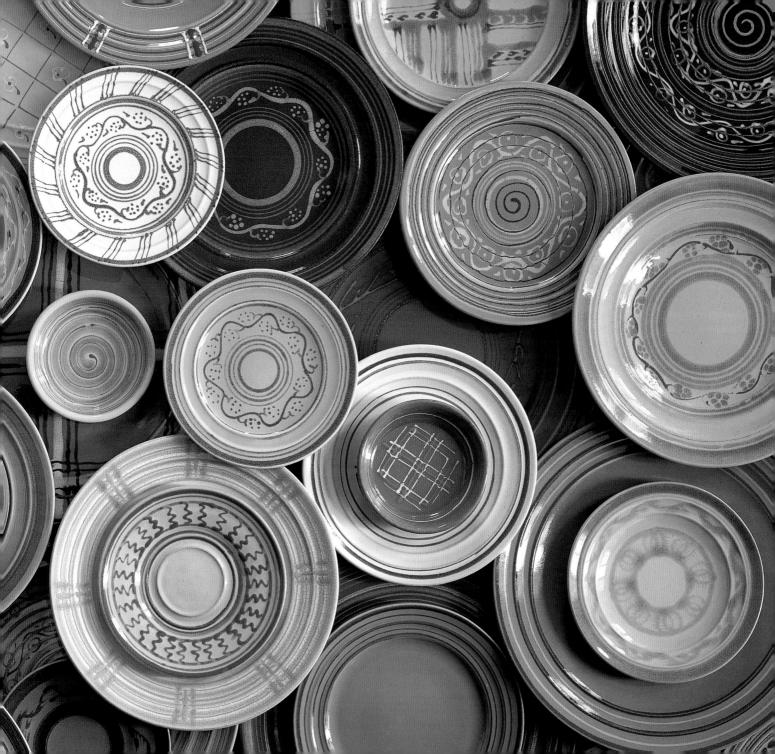

Vernon Kilns, Vernon
Polychrome A plate. B310
carafe. Tropical Fish demitasse
cup and saucer by William
"Harry" Bird. c. 1936.

president of the company, contracted with some of the best decorators and commercial artists of the day. In 1935, William "Harry" Bird, a modern colorist par excellence, began working for the company. Bird, who had previously operated his own pottery in Pasadena, used a patented method for applying colored glazes he called "Inlaid Glaze" although the color is, in fact, so thick that it rises sufficiently above the surface of the clay to produce a sculptural effect. Bird came to Los Angeles in about 1910, after working in Ohio potteries and seems to have been at Vernon for about two years, during which time he created some seventy designs for the company, several of which still look remarkably modern. (In the early forties, Harry Bird and his second wife, Martha Bird, worked for Wallace China Co., which had been making restaurant wares in Huntington Park, just south of downtown Los Angeles, since 1931, and where she designed the Dahlia pattern.)[3]

By 1937 the remarkably prolific decorative artist Gale Turnbull, who had worked at Leigh Potteries in Ohio, was creating the more than one hundred designs he would make for Vernon Kilns. The floral decorations he had made for Leigh give no hint of the strength and variety of the work he would produce while at Vernon.

Turnbull's paintings reveal the hand of a deft draftsman and the eye of an imaginative decorator. In his American landscape paintings, Turnbull reflects an idealization of nature and industry with stylized factory buildings shaded in the same palette as the surrounding blue, lavender, and lime-green hills. Although little biographical documentation is extant regarding Turnbull, he was in northern France—perhaps as a soldier—in 1917[4] and a series of watercolors indicates that he traveled in Brittany and perhaps Spain, probably between his departure from Ohio in 1935 and his arrival in California in late 1936. Elements of some of those watercolors show up in designs he created for Vernon

Catalina Pottery, Avalon
Undersea-decorated plate.
c. 1930.

Wallace China Co., Huntington Park

Dahlia pattern dinner plate, cereal bowl, and butter pats by Martha Bird. c. 1945.

Kilns. In just one or two years Turnbull produced images ranging from conventional florals to painterly desert scenes to modern color experiments that were executed by his own staff of hand painters. Even though many of his patterns were promoted in company brochures and ads, it appears that most—like the Native America series and Coastline, one of Turnbull's most idiosyncratic designs, a dinnerware service on which he outlined sections of America's ocean and lake shores—were limited-production items. A few, including the plaid Organdie pattern, did go on to be full-production successes, and during the post–World War II Rural Revival the company developed other plaid color combinations named for traditional fabrics.

In 1938 Vernon Kilns gave a design contract to Don Blanding, a facile artist and flamboyant, self-promoting poet who appears to have been a cross

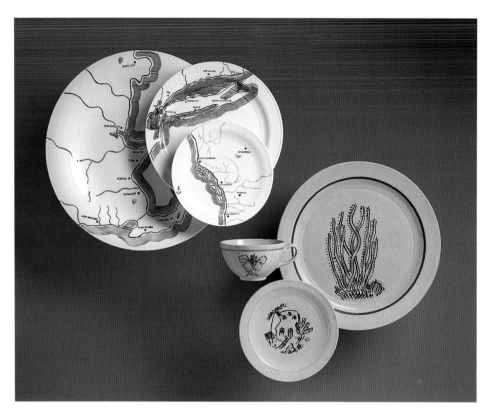

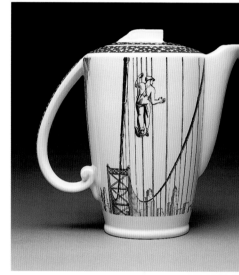

between Rod McKuen and Orson Welles. (Blanding aficionados have been heard to exclaim: "What? You have a rare *un*autographed Don Blanding book?") He was a deft sketcher of Hawaiian floral and fish motifs, which illustrate numerous books, and several Vernon Kilns' dinnerware patterns with names like Glamour, Joy, Delight, and Ecstasy.

In the same year Vernon Kilns commissioned the artist/book illustrator Rockwell Kent to create designs for three dinnerware services. Moby Dick draws on the artist's popular illustrations for Herman Melville's novel, and features the whaling ship *Pequod* and Moby-Dick himself dramatically leaping through the waters. Salamina was based on Kent's illustrations for his book of the same name, an account of his sojourn in Greenland and of Salamina, an Eskimo woman with whom he reportedly fell in love. Kent's images for Our America express the artist's

Vernon Kilns, Vernon

far left
Coastline chop plate, salad plate, saucer; Banana Tree cup; Little Mission saucer; Cactus No. 3 dinner plate. Designs by Gale Turnbull. c. 1936.

top left
Our America coffeepot decoration by Rockwell Kent. 1940.

bottom left
Salamina tureenette decoration by Rockwell Kent. 1939.

socialist beliefs, even though this series was clearly intended to be a traditional glorification of American life. Taken as a whole, the images reflect both the economic and social culture of the time and the transition of America from an agrarian to an industrial economy. The scenes were apparently intended to be generic: great cities, a major dam, stern-wheelers, boating, an adobe. Some, however, are too iconic to be generic: the southern tip of Manhattan Island, a drawbridge over the Chicago River, among others. And in some scenes, such as the construction of a skyscraper and the building of a great bridge—the Oakland–San Francisco Bay Bridge, judging by the cross members in the towers—he foregrounds workers depicted in the Socialist Realist style. Even more telling is the principal image representing the American South, which shows a plantation mansion in the background and in the foreground a Negro woman, as she would have been called then, on her knees picking cotton. Next to her a man looks at the big white house as if to say of her work: "This is what paid for it." Not a far-fetched analysis, as cotton would never have been planted, much less picked, on the front lawn of the master's home.

Kent's politics did not prevent Walt Disney from making an arrangement with Vernon Kilns to produce movie tie-in pottery. In 1940 Vernon was authorized to produce dinnerware, vases, flower bowls, and figurines inspired by the film Fantasia. Some of the dishes show Dewdrop Fairies waving their wands amidst flowers as big as they are. Decorative figurines by California potteries, although not part of this survey of practical pottery, are other early examples of the now endemic motion-picture tie-in product. From 1938 to 1940 Durlin Brayton's Brayton-Laguna Pottery made the first pottery Disney figures.[5] These included Snow White and the Seven Dwarfs, Pinocchio, Donald Duck, and Mickey Mouse. In the 1940s, Vernon Kilns acknowledged the film industry in another way with a Hollywood souvenir plate, one of hundreds that com-

 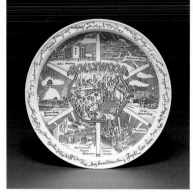

memorated places and people and were part of the company's bread and butter.

The imaginative use of color by Winfield of Pasadena in the mid-1930s has been virtually forgotten, although its rustic shapes would continue to be made by Winfield and subsequently by American Ceramic Products for two decades. In the late thirties Winfield ceased producing colored dinnerware and began decorating its dinnerware with Chinese- and Japanese-inspired designs. Margaret Mears Gabriel, who with her husband would soon own the company, produced many of the company's Asian-influenced decorations. Later, other painted decorations were created by noted Chinese-American artist Tyrus Wong, who participated in the Federal Art Project in the 1930s and painted the backgrounds for Walt Disney's 1942 animated film *Bambi*. Japanese-American artist Benji Okubo[6] was responsible for the decorations for several dinnerware lines, including the popular Bird of Paradise, which was produced by American Ceramic Products of Santa Monica (to which Winfield licensed its name when the Pasadena company could no longer keep up with the flood of orders coming in during the postwar economic boom).

World War II officially started in September 1939, when Germany invaded Poland. Even though the United States wouldn't become a combatant in Asia until December 7, 1941, and in Europe until December 11 of that year, a September 9, 1940 *Life* magazine article entitled "American Dishes: Home Product Fills the Gap Made by War and Boycott," was already reporting on its consequences

from left
Daniel Gale Turnbull
Painting on unmarked 14-inch Vernon Kilns plate. signed lower right "Gale Turnbull." Wedding gift to Jane Bennison and her husband. B. N. (Bud) Howell. 1939.

Vernon Kilns, Vernon
Souvenir plate. Hollywood. c. 1945.

Winfield Pottery, Pasadena
Decoration by Tyrus Wong. c. 1945.

Vernon Kilns, Vernon

Dewdrop Fairies pattern (detail).
Fantasia series. 1940.

Footnotes

1 Hazel V. Bray, *The Potter's Art in California* (Oakland: The Oakland Museums, 1980), p. 2.

2 Catalog: *The Armstrong Shop, Buffalo, N.Y. Importers, White China for Decorating,* c. 1920.

3 Conversation between Bird's granddaughter Beverly Shan and the author, November 10, 1999.

4 Viz.: a drawing of soldiers in a French town signed "Daniel Gale Turnbull, Soissons, 1917." Collection: Adrianne Dicker.

5 Jack Chipman, *Collector's Encyclopedia of California Pottery,* 2nd edition (Paducah, Kentucky: Collector Books, 1999), p. 57.

6 During World War II, Los Angeles–born Okubo (1903–1975) was interned for more than three years at the Heart Mountain, Cody, Wyoming Relocation Center.

for the American dinnerware industry. For years, *Life* said, American retailers had been going to "Czechoslovakia, Germany, Austria, Italy, France, England, and Japan." Then "the war cut off all imports from Europe except England. Boycott and general sentiment against low-cost labor curtailed imports from Japan." And with shipping from England soon to be halted by the torpedoes of German U-boats, California potteries rushed to fill the resulting void in the dinnerware and ornamental ceramics markets. Perhaps the most telling reaction was that of Vernon Kilns of Los Angeles, which had been a pioneer in modern design in the thirties. Vernon turned to producing dinnerware patterns—including May Flower, Fruitdale, Chintz, and others—that aped traditional flower- and fruit-filled English designs long popular with some Americans but no longer available in stores. For a brief time, and undoubtedly for the same reason, Pacific Clay Products produced vases and dinnerware with floral decorations before it turned its production over to the war effort in 1942.

As we will now show, the war years saw California Pottery stake a claim to still another kind of popular imagery.

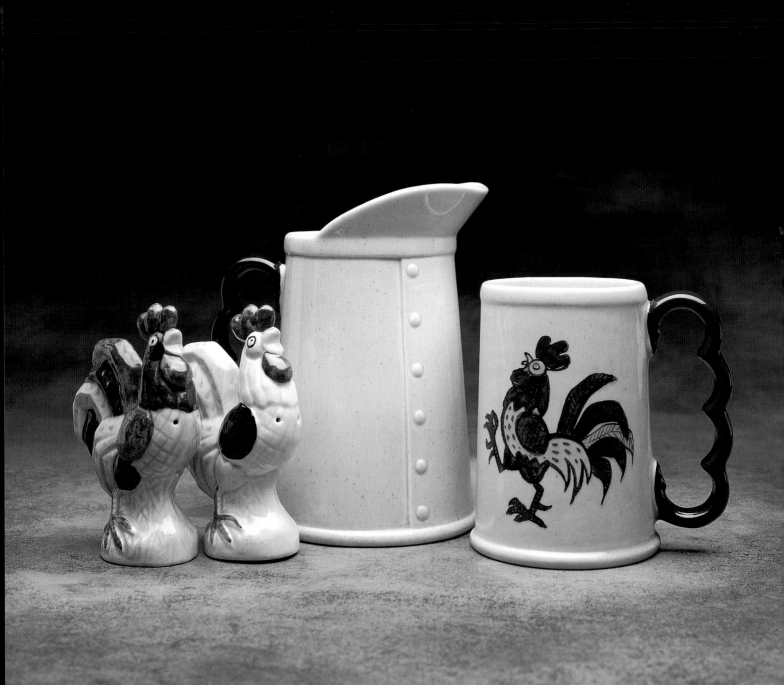

Chapter 6 : RODEOS and ROOSTERS

Metlox Potteries, Manhattan Beach

left
California Provincial pattern.
1949–1982.

above
Brochures. 1950s.

Texas longhorns in your kitchen? Cowboys on your lamps? A rural mailbox on your dining table? Is this a parallel universe? Of course it is. The path taken by California Pottery in the 1930s may have looked like a straight shot to Modernism, and, sure enough, it did get there. But things are rarely that simple. On the way, historical and social forces, to say nothing of fundamental differences in taste, led California Pottery down a couple of quite different roads as well.

At the beginning of the twentieth century, with nostalgia growing for the then disappearing American frontier, a decorative movement called the Rustic Revival appeared. Its look, popularized by Teddy Roosevelt and Will Rogers, relied on log buildings, saddles, and other artifacts of the Old West, as well as Navajo rugs and other American Indian crafts. Toward the middle of the century, nostalgia for the Old West and the newly imperiled American family farm—embodied in a homegrown design movement called the Rural Revival—struck that same sentimental chord.

The Rural Revival's idealized imagery of pristine farms, hardworking cowboys and well-stocked chuck wagons offered the spiritual comforts of

simplicity and certainty in a time that was as preoccupied with air-raid drills and bomb shelters as it was with bowling and barbecues. And California was one of the engines of this style that looked back to a time before the forces of change—industrialization, atomic energy, modern design—had started to remake the world in unfamiliar, even threatening, ways. By the late forties, farm and ranch themes were adorning all sorts of California-made products: shirts, bathing suits, neckties, bedspreads, curtains, ashtrays, and, of course, pottery.

When World War II ended in 1945 the United States was the only major industrialized nation to come out of it undamaged. Not only were factories intact and still up and running, but they would soon be gearing up to provide new and replacement products for friend and former foe alike, and a large workforce, including decommissioned service personnel, would be available to do the work. When they returned from Europe and Asia many of those servicemen and -women did not go back to live on the farm or in the hometown they had left. Hundreds of thousands of them joined the hundreds of thousands of other Americans who had already moved to newly industrialized areas during the war. Many came to California, where they helped in the manufacture of automobiles, aircraft, ships, steel, plastics, tires—in the 1940s Los Angeles was second only to Akron, Ohio, in tire production—and in the construction of the homes needed to house themselves and other workers. Between 1941 and 1951 more than three million people migrated to California, and in the mid-war year of 1943, 684,000 people came to the state, over fifty percent more than any other year before or since.[1]

In 1951, with the postwar economy booming, you might have moved from a traditional house in a small town or a farm to, let's say, one of the 17,500 just-built tract houses in and around Lakewood, near Long Beach, California.[2] Although this was "the good life"—a steady, well-paying job, your own house, a

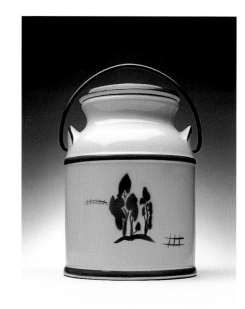

B. J. Brock and Co., Lawndale
Harvest pattern cookie jar.
unmarked. c. 1950.

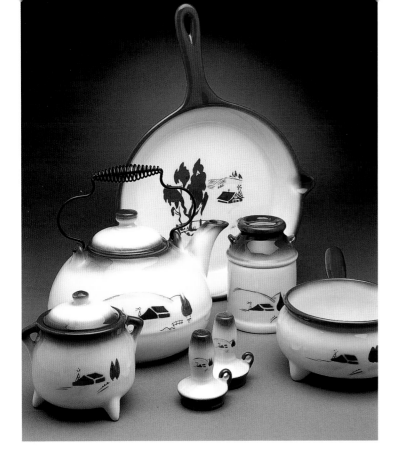

B. J. Brock and Co., Lawndale

Harvest pattern. c. 1950.

Mark: Brock of California

One of several used by B. J. Brock.

car, a barbecue—you and your family would probably have felt estranged, cut off, out of context. Back home you had lived with the same familiar architecture since birth and you would have lived with at least the vestiges of a rural heritage: a milk can, a flatiron, a potbellied stove, some homespun fabric. But now, in your new house, everything from the window frames to the treeless landscape was alien and you just didn't feel at home.

This uprooting of so many people from their social and familial contexts and their transplantation to unfamiliar urban and suburban settings contributed to the popularity of the Rural Revival. It was an American style that, in a period filled with nationalism, prosperity, and the glorification of the waning American farm, appealed not only to the uprooted but also to those still living on farms and in rural towns. As popularized by movies and television, this attempt to hold on to the traditional, if not the familiar, also made serious inroads into urban life. My own role models included Gene Autry, Roy Rogers, and the Lone Ranger: although we didn't go so far as to eat off plates with bucking broncos on them, there I am in a photo taken in front of our apartment house in New York City, the six-year-old son of a doctor whose parents had been born in Russia, wearing a fringed jacket, cowboy hat, and boots and brandishing a toy Colt pistol. What could be more American?

As a design phenomenon, the Rural Revival, which remained vital for two decades after the war, was largely a California-driven marketing device. From Western shirts and ties with the "H BAR C California Ranchwear" label to

swimsuits and wall-paper and dinnerware, California-made products, abetted by Western movies like *Winchester '73* (1950) and television series like *Gunsmoke* (1955–1975), penetrated the market by appealing to a fantastical, preindustrial age.

When it came to Rural Revival pottery in particular, California rode roughshod over the competition, its farm imagery reading like a turn-of-the-century Sears Roebuck catalog: from Vernon Kilns, a series of dinnerware services in farm-house patterns—Homespun, Gingham, Calico, Organdie, and Tweed—and its RFD (Rural Free Delivery) pattern; from B. J. Brock and Co., Harvest; and from Metlox Potteries of Manhattan Beach, Country Side, Red Rooster, Homestead Provincial, and California Provincial. "Provincial" was the name several manu-facturers gave, without the slightest hint of irony, to their farm-themed products. Brock's Harvest (c. 1950) was made on a shape the company oxymoronically called Modern Provincial, and Metlox Potteries' Provincial shape was made up of eighty or so pieces that included adaptations into pottery form of such sentimental objects as tin pitchers, cast-iron cauldrons, and steel milk cans complete with pottery rivets and adorned with images of bucolic farm life. Metlox's Provincial patterns, cleverly, if improbably, marketed as offering "Antique Flavor . . . Modern Design,"[3] were popular enough to stay in production until 1980.

Another trail broken by the Rural Revival led to rodeo, ranch, and Old West imagery. The rodeo theme in pottery (well, vitrified restaurant-grade dinnerware, anyway) got a head start in 1943 when the M. C. Wentz Company, a

Vernon Kilns, Vernon

R.F.D. (Rural Free Delivery) butter dish by P. L. Davidson. 1951.

Footnotes

1 California Department of Finance, Demographic Research Unit, January 1999.

2 "Lakewood Park Corporation built and sold 17,500 houses by 1953 in what are now Lakewood and the Carson Park area of Long Beach. *Time* magazine reported in 1950 that this was the largest housing development in the world." City of Lakewood Web site, www.lakewoodcity.org, April 5, 2000.

3 Metlox Potteries brochure, 1959.

4 In addition to the Till Goodan designs, Wallace produced several uncredited Western patterns, including El Rancho, Chuck Wagon, and an unnamed cattle brands pattern.

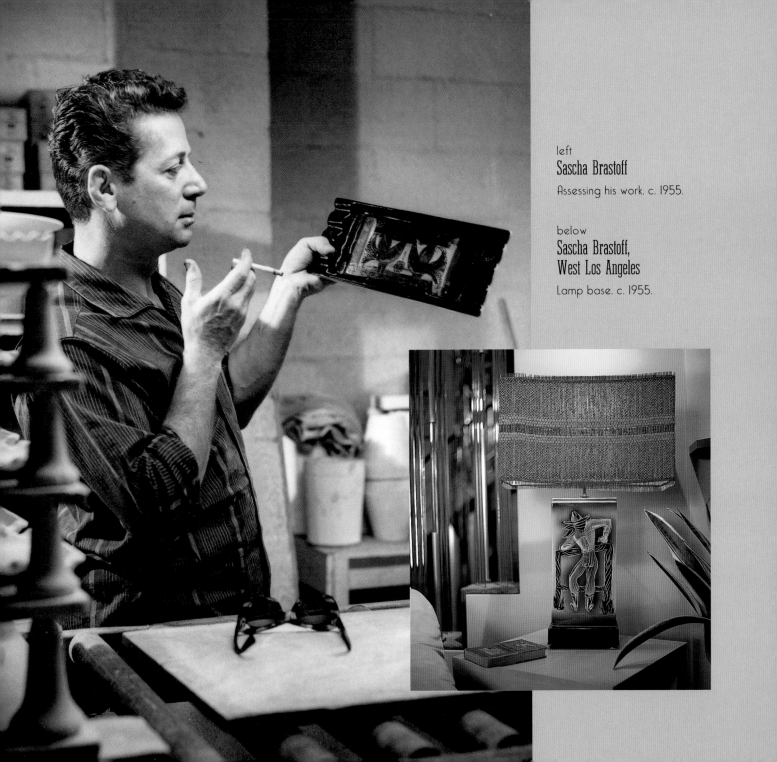

left
Sascha Brastoff
Assessing his work. c. 1955.

below
Sascha Brastoff,
West Los Angeles
Lamp base. c. 1955.

Pasadena housewares distributor, commissioned Wallace China Co. to produce a line of durable barbecue wares with its Westward Ho decorations. Paintings for several dinnerware patterns were executed by Till Goodan, a noted Western illustrator: the monochromatic Boots & Saddle, which, not surprisingly, features boots and a saddle, along with cattle brands; Pioneer Trails, whose signature motifs are the covered wagon and the stagecoach; Longhorn, with its dramatic long-horned steer heads; and the hand-tinted Rodeo pattern, admired for its action scenes of buckaroos and steer wrangling.[4]

Wentz's go-along accessories for its dinnerware, produced in paper, glass, and leather, were all appropriate for the exigencies of backyard barbecues and restaurant use. The dinnerware remained in production through 1961.

Most of Wallace's heavy, vitrified china dinnerware was made for sale to restaurants, which sometimes had their names added to the design This was the kind of stuff you could throw across the room and expect it to break something, not the other way around. (However, these days, with dinner plates featuring Till Goodan decorations selling for more than fifty dollars apiece, you might not want to test it.) Naturally, Goodan's Little Buckaroo Chuck Set for children, which shows a child on a rearing horse with the legend "Ride 'Em, Cowboy!" was also made to stand up to abuse.

The prolific ceramic designer and former dancer and department store window dresser Sascha Brastoff also appreciated cowboys. After serving in the U.S. Army in World War II, during which he had a career entertaining the troops by impersonating Carmen Miranda,[5] Brastoff came to Los Angeles in 1945, worked as a costume designer at the 20th Century Fox film studio, and then in 1947, with funding from Winthrop Rockefeller, established a ceramics

Mark: Westward Ho Rodeo Pattern

Wallace China Co., Huntington Park. c. 1940s.

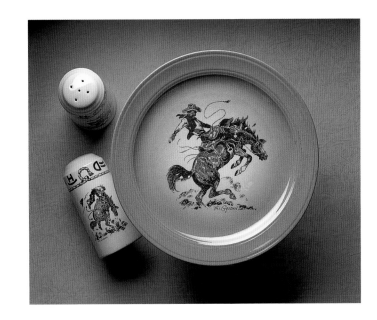

Wallace China Co., Huntington Park

Rodeo shakers. decorated by Till Goodan. 1943–1961.

Vernon Kilns, Vernon

Till Goodan decoration on airbrushed plate. unmarked.

5 Steve Conti, coauthor with A. DeWayne Bethany and Bill Seay of *Collector's Encyclopedia of Sascha Brastoff: Identification & Values* (Paducah, Kentucky: Collector Books, 1995). Conversation with the author, March 21, 2000.

6 In 1953, the name Winchester '73 was changed to Frontier Days following a dispute with the Winchester Arms Company. Nelson, *Collectible Vernon Kilns* (Paducah, Kentucky: Collector Books, 1994), p. 159.

company in West Los Angeles. Although much of the company's enormous output over a period of some twenty-five years would be done by assistants working from his designs, Brastoff painted most of its early products himself. They include a lamp base with the image of a cowboy leaning against a corral fence, and a western-themed dinnerware service.

Vernon Kilns contributed to the Old West category with its Winchester '73 pattern, created in conjunction with the 1950 Universal International movie *Winchester '73,* directed by Anthony Mann and starring James Stewart and Shelley Winters.[6] The dishware was decorated with hand-colored transfers depicting scenes of ranch and frontier town life.

Eventually interest in Western themes began to wane. However, tastes come and go and often come back once again. And so in chapter 8 we will see the Rural Revival revived. But now that we've caught up with the past, for the moment anyway, it's time to get back to the future.

Chapter 7 : MEETING MODERNISM

Barbara Willis, North Hollywood
Square flower floater bowl.
c. 1945: low bowl. c. 1945: and
rectangular vase. c. 1950.
These cast pieces show the
popularization of techniques
used by studio potters.

From the late 1930s, the influence of modern studio potters was felt both directly and indirectly in commercial pottery production in California: Glen Lukens was the teacher of Jane Bennison at the University of Southern California in Los Angeles; Barbara Willis studied with Laura Andreson at the University of California at Los Angeles. The work of such influential potters as Otto Heino, who taught at USC and the Chouinard School of Art, and his wife, Vivika Timeriasieff Heino, and Otto and Gertrud Amon Natzler, whose work was exhibited at the Second California Ceramic Exhibition in 1939, was well-known at the time.

Between 1939, when the war in Europe began, and until after the war ended in 1945, most of the nation's commercial design and production efforts were channeled into the defense effort: Among the big California potteries, the J. A. Bauer Pottery Co. produced dinnerware for the U.S. Navy at its Atlanta, Georgia, plant. In 1942, Pacific Clay Products stopped making retail wares and turned virtually its entire production to military contracts. What Pacific Pottery made for the war effort is not known, but perhaps, like Syracuse China in Syracuse, New York, it included ceramic antitank mines.

During the war hundreds of small potteries opened in California, hoping to profit from the dearth of ceramic products from traditional sources. Most of what these mom-and-pop operations produced were imitations of English and Japanese decorative and functional figural items. But the first post–World War II decade, 1945 to 1955, was a time of innovation out of which much of the subsequent good design in American ceramics would develop. It was the period in which California pottery marched into Modernism, hitting its stride in the late forties and early fifties with Futurist shapes and Calder-inspired decorations from Metlox Potteries in Manhattan Beach and International Modern forms from Architectural Pottery of Los Angeles. California Pottery was once again on the leading edge of the American lifestyle.

After the war it didn't take long for California's Big Five minus one—Bauer; Gladding, McBean/Franciscan; Metlox; and Vernon (Pacific didn't resume retail production after the war)—to add Modernist designs to their production of dinnerware and other housewares. But even before the big boys weighed in, the modernist era was heralded by two young female ceramists, Barbara Willis and Edith Heath, who would make a lasting contribution to the quality of commercial

Artware line by Russel Wright (1904–1976). From top: pillow vase. so-called Manta Ray bowl. and oval bowl. 1946. Volcanic glazes give a studio-pottery look to these commercially unsuccessful. but aesthetically significant. cast pieces.

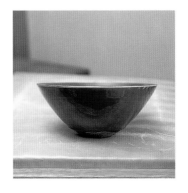

ceramic design in America. Their work had a strong impact then, and is even more appreciated now, due to its unprecedented introduction of studio pottery techniques and aesthetic standards into commercial pottery production.

In 1941, with her husband off in the Air Corps, twenty-three-year-old Barbara Willis got serious about making pottery at her home in Los Angeles. Willis had studied at UCLA with the noted studio ceramist Laura Andreson, whose hand-thrown work was known for its combination of bisque and crackle-glazed clay. In her work, which was made in molds and not handmade,[1] Willis used the same technique including the crackle-glaze, in what at the time were cutting-edge glaze colors: intense turquoise, citron/chartreuse, and deep Chinese red, colors that seem to have been made to order for today's Modernist revival sensibility.

In Willis' work we see once again the democratizing aspect of California Pottery. By adapting the essence of Andreson's handmade technique to a commercial production method, Willis and her fifteen employees were able to produce pieces that looked handmade and make them available to the general public at a fraction of the cost of individually thrown pieces. According to Willis, at that time a piece of her work that would retail for five dollars was comparable to one of Andreson's that would have cost five times as much.[2] It is not by accident, Willis says, that her early output looks so handmade. Those holes the size of grains of sand in the unglazed underside of her bowls? "I put grog [pulverized, prefired terra-cotta] in the clay, which would be revealed when the greenware [still-wet, unfired clay] was scraped with a knife."

top
Laura Andreson, Los Angeles
Hand-thrown bowl, crackle-glaze and bisque. 1944.

above
Barbara Willis, North Hollywood
Cast low bowl, underside (detail) showing mark and hand finishing. c. 1945.

And the scratch marks? "I gave the finishers wire brushes to scrape the clay with." And the variations in the signature incised in her products? "My mother liked signing them, but some of my pieces didn't get signed at all because the finishers [who usually did the job] would get tired of doing it."[3]

If Barbara Willis' motivation for popularizing high-art ceramics was principally commercial, the decision of Edith Heath to cease throwing pottery and to go into production was not a simple business decision. She wanted her work to be available to more people than could afford her individually made pieces. Heath began her career in 1942 by making slab pottery tableware in her San Francisco apartment. Even though some of her early work appears to have the regularity of cast pottery, it was, she says, actually rolled out like pie dough in her kitchen. And the nubby surface it sometimes had? "I rolled the clay out on burlap."[4] Heath had her first individual show at San Francisco's Palace of the Legion of Honor in 1943. The exhibition was seen by Richard Gump. His store, Gump's, a San Francisco institution that had been promoting California design and craft since the 1930s, financed a studio for Heath. Her work was exhibited in the store's Discovery Shop and sold exclusively at Gump's until she established her own company.

Heath's decision to turn from studio work to commercial production came after her work was seen at San Francisco's Merchandise Mart in 1946 by representatives of Marshall Field's (Chicago), Neiman-Marcus (Dallas), and Bullocks-Wilshire (Los Angeles) because, she says, "I couldn't possibly do anything in the way of any quantity with two or three people. Besides, the machines don't think; it's the people who do the thinking." In 1949 Sheila Hibben observed in the *New Yorker* that "Mrs. Heath's stoneware, though machine-made, is produced in relatively small quantities, and she has managed to retain an astonishing feeling of

far right
Edith Heath, San Francisco
Hand-thrown pottery. Larger pitcher ink-marked "43 Heath." others incised "E. Heath." c. 1944.

right, top to bottom
Heath Ceramics, Sausalito
Teapot by Edith Heath. designed c. 1949. Still in production.

Cast lidded bowl with bubbly interior by Edith Heath. c. 1950.

Dinnerware. decorative tile. ceramic sign by Edith Heath. current production.

Mark: Heath Ceramics
Sausalito. c. 1990.

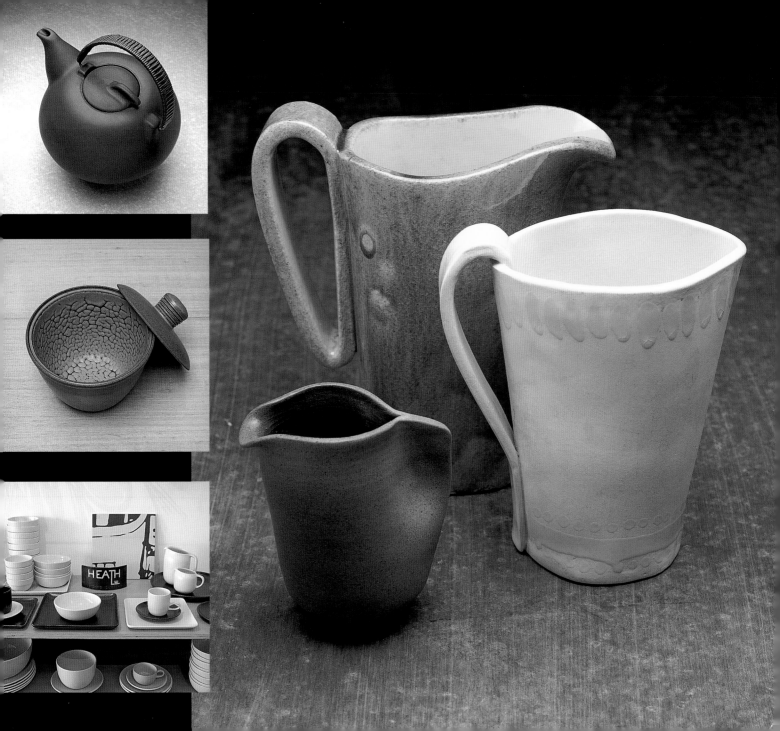

spontaneity and freedom in her forms."[5] Nonetheless Heath's decision made her unpopular with her fellow potters, who saw this as a sellout of her artistry. In 1958, in an effort to make peace with her dissenting colleagues, she invited several of them, including Polia Pilin and Marguerite Wildenhain, to participate in a seminar on the subject of studio versus production pottery.[6] Heath says that they came away still believing that "if you didn't throw each piece by yourself, it couldn't be a work of art"[7] and that after the conference the participants shunned her.

Nonetheless, Heath's designs are in museum collections, including the permanent collection of the Museum of Modern Art in New York. Architect Philip Johnson, a consultant on the design of the Pasadena Museum of Art (now the Norton Simon Museum), chose Heath to create the building's tile exterior. In 1971 she was awarded the only Industrial Arts Medal for architectural tile given by the American Institute of Architects. Heath tile installations also grace the Los Angeles County Museum of Art, the Yerba Buena Center for the Arts in San Francisco, and the Hong Kong National Bank in Hong Kong.

Just a few years after Metlox Potteries of Manhattan Beach produced the retro Rural Revival forms and designs of its Provincial dinnerware lines, the company flirted with Modernism. In 1954 Metlox released its California Freeform shapes, which included a towering coffee server, a boomerang side dish, and a bow-tie vegetable bowl. The radical forms and multicolor decorations inspired by Alexander Calder mobiles were by Frank Irwin.

In the 1950s, in the face of growing competition from imports of fine china from the sources that had been cut off during the war—notably England, Germany, and Japan—Gladding, McBean began production of its Fine China porcelain dinnerware, much of it ornamented with floral patterns and some with gold trim. In 1954, using the same thin body as the Fine China line, George T. James

Metlox Potteries, Manhattan Beach
California Freeform tumbler and coffee server by Frank Irwin. 1954.

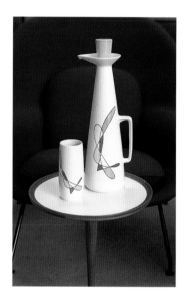

Gladding, McBean & Co., Los Angeles
Franciscan Fine China. The company's initials discreetly ornament this small dish by George James. c. 1956.

right
Riverside China, Riverside

Dinnerware with handleless pitcher
designed by Eva Zeisel. 1947.

above
**Gladding, McBean & Co.,
Los Angeles**

Franciscan Fine China. Contours
double vase designed by
George James. 1955–1956.

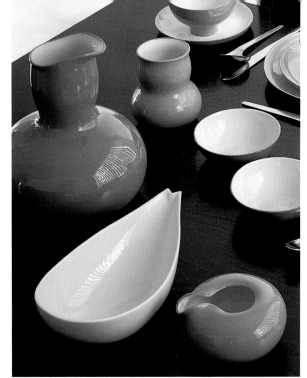

created a series of Modernist vases, candleholders, and covered vessels called Contours.

James, who was born in Lowell, Massachusetts, received a degree in industrial ceramic design from the Alfred School of Clayworking in Alfred, New York. Among the several dinnerware shapes he designed for Gladding, McBean is Eclipse, reminiscent of the craft-influenced shapes designed by Glidden Parker for his pottery in Alfred. Eclipse was used for a number of Franciscan Ware patterns, including the "atomic" looking Starburst (by Mary C. Brown), which seems to be even more popular today than when it was released successfully in 1953. James' Contours line was made in forty shapes and six colors; many of the shapes available with decals designed by James.

At his plant in West Los Angeles, designed by architect A. Quincy Jones, Sascha Brastoff produced large quantities of ceramic dinnerware and accessories, including lamps, ashtrays, masks, tiles, wall plaques, tea canisters, and cigarette lighters. Brastoff received numerous commissions to create commemorative, souvenir, and business promotional items. Among the latter were several items Brastoff created for Fiesta Pools, a Los Angeles–area swimming pool builder.

Until now the California production pottery that has received perhaps the most attention is a set of dinnerware by Eva Zeisel, a Hungarian-born

ceramist who worked in the Bauhaus style in Germany in the late 1920s and then in the Soviet Union before coming to the United States in the 1930s. Zeisel is known for her ergonomic shapes, among them the characteristic handleless pitcher (see previous page). Although made in different shapes for different dinnerware services, these pourers can all be held securely without the usual attached appurtenance, which is both a costly part of production and prone to breaking with use. This porcelain-like service[8] was produced in about 1947 by Riverside China of Riverside, California, about which little is known.[9]

 There are actually hundreds of California potteries about which little or nothing is known but their mark—virtually every time I go to a flea market I see one or two I have never seen before. Many of their designs are derivative, but even among the up-till-now anonymous producers, fresh design finds can be made. Take Vadna of California, for example: several semiporcelain dinnerware

Vadna
of
California

above
Vadna, Leucadia
Soup bowl. tumbler. bread and butter plate. creamer: ink-marked "Vadna of California." one of hundreds of undocumented California potteries. c. 1950.

far right
Mark: Vadna of California

lines by this pottery have been seen, among them a distinctive Modernist two-color service with applied wooden handles and bases. The glaze and the thin body show Asian influences, but the solid half-disc cup and soup bowl handles, which fit into in-mold grooves, echo an all-ceramic Bauhaus shape produced in Germany in 1928.[10] It is doubtful that this will be the last "unknown" California pottery to be recognized for its good design.

Our survey of California Pottery ends with a company whose designs have had such a strong impact on the way many of us live that, as this is being written, plans are being made to reproduce many of them. Unlike any other commercial California pottery, Architectural Pottery, established at the midpoint of the twentieth century, was honored right from the beginning. Designs from its first catalog were selected for the 1951 Good Design Exhibition at the Museum

Architectural Pottery, Los Angeles

left
"Egg" planter by Rex Goode.
c. 1950.

above
Inverted cone planter with
original walnut frame. by
LaGardo Tackett. c. 1955.

94

Footnotes

1 A photo caption in the Museum of Modern Art's *How to Make Pottery and Ceramic Sculpture* (New York: Simon and Schuster, 1947), p. 55, refers to "Slab Pottery by Barbara Willis," i.e., pottery assembled by hand from components cut from slabs of clay. Ms. Willis attributes this mistake to her success in making her work *look* handmade. Conversation with the author, March 16, 2000.

2 Ibid.

3 Ibid.

4 Conversation with the author, June 10, 1999.

5 Sheila Hibben continues: "Not that there is any attempt to disguise the up-to-date mechanical processes involved; on the contrary, part of the charm of the ware is its frank admission and respectful observance of the limitations of the machine." "On And Off The Avenue: About the House." *The New Yorker*, September 17, 1949, p. 80.

of Modern Art in New York. Its products brought the aesthetic purity of Modernism—with the ideal of good design for all—to the concept of the blending of interior and exterior first fostered by the Spanish Colonial Revival. Looking back on the company that she and her husband, Max, founded in 1950, the late Rita Lawrence observed in a 1965 interview: "Architectural Pottery provided a portable landscape and a focal point in garden plantings, then carried the motif into the home and office."[11] California Pottery was again at the forefront of the American lifestyle.

The first Los Angeles residences of Rita Lawrence, a UCLA graduate, and her husband, Max Lawrence, a New York businessman, were "modest, but modern homes designed by Gregory Ain."[12] Their first was one of Ain's famed Dunsmuir Flats, an apartment with a living room that flows out onto a sizable terrace. They subsequently lived in an Ain house whose sliding walls allowed for flexible use of its limited, 1,500-square-foot space.[13] Around 1950, Max Lawrence recalls, Rita was impressed by an exhibition of ceramics made by students of LaGardo Tackett at the California School of Art, and the Lawrences established Architectural Pottery to produce them.[14] For several years, before acquiring its own production facility, its wares were made by Gainey Ceramics, when that pottery was located in Manhattan Beach, southwest of Los Angeles. (Gainey has since moved to La Verne, east of Los Angeles.)

Among the Architectural Pottery designs selected for the 1951 Good Design Exhibition was the "egg" planter that had been designed by LaGardo Tackett's student Rex Goode. In 1953, Architectural Pottery added sand urns and a wide range of new designs to its catalog, among them Tackett's inverted cone and his Trail Blazer Award–winning Hour Glass. Over the years the company employed a number of other first-rate designers, among them John Follis,

Mary Kay Austin, Douglas Deeds, Elsie Crawford, Malcolm Leland, and Lawrence Halprin.

After designing ceramics and other wares in Japan, Tackett came back to Los Angeles with drawings and said to Max Lawrence: "Make these." Mr. Lawrence recalls replying: "No one's going to buy white cylinders." To which Tackett answered: "Never mind, just make them."[15] Before long, those white—and occasionally colored—cylindrical planters, introduced by Architectural Pottery in the 1960s, would become ubiquitous, showing up in homes, gardens, and office buildings throughout the United States and abroad. Architectural Pottery, which, Rita Lawrence said, "was originated to make a statement about today's way of life, not to imitate or adapt the past,"[16] closed in 1985.

Perhaps the best assessment of the products made by the Lawrences came from architect A. Quincy Jones: "Their belief in the integrity of the artist and the importance of using modern materials and methods to the best advantage has led to the production of objects recognized the world over for their quality of design. And, I add, the repetitiveness of a well-designed object in no way decreases its [aesthetic] value."[17]

The same, of course, applies to all the best California commercial pottery.

6 This event should not be confounded with the 1957 crafts conference held in Asilomar, California.

7 Ibid.

8 Made from a clay body high in kaolin, a mineral which when fired at high temperatures vitrifies to a china-like hardness.

9 This dinnerware service "was made in Riverside, California, by a man who went up into the mountains—I don't know which ones—and found minerals for making beautiful glazes." Eva Zeisel, conversation with the author, April 24, 2000.

10 Schramberger Majolicafabrik cup: Charles Venable, *China and Glass in America 1880–1980: From Tabletop to TV Tray* (New York; Harry N. Abrams, 2000), p. 229.

11 Elaine K. Sewell Jones, Manuscript Collection number 1587, Architectural Pottery. Department of Special Collections, UCLA Library, Los Angeles, California.

Architectural Pottery, Los Angeles

Triennale. totem garden
sculptures by LaGardo Tackett.
c. 1955. are reminiscent of
Constantin Brancusi's "Endless
Columns" (1918 to 1937).
Photo: Bill Stern.

12 Conversation with the author, March 27, 2000.

13 Ibid. "Those walls were heavy, I don't know how we moved them."op cit.

14 According to Sheila Hibben, works by "the California potter La Gardo [*sic*] Tackett" were "startlingly fanciful in design; one might overlook their excellent craftsmanship while admiring their lively wit." *The New Yorker,* September 17,1949, p. 78.

15 Conversation with the author, March 27, 2000.

16 UCLA Oral History by Elaine K. Sewell Jones.

17 UCLA Library, op. cit.

Chapter 8 : THE END of the RAINBOW

**J. A. Bauer Pottery Co.,
Los Angeles**

Plainware mixing bowls (left).
c. 1930.

Meyers Pottery, Vernon

California Rainbow mixing
bowls (center). c. 1935.
Japan. Cactus salt and pepper
shakers. unmarked. c. 1930s.

Meyers Pottery, Vernon

California Rainbow low bowls
(right). unmarked. c. 1935.
California Rainbow casserole
(lower center).

**J. A. Bauer Pottery Co.,
Los Angeles**

Cylinder vase (foreground).
c. 1950.

If ever a Golden Age was misnamed, it was California Pottery's. Except for some gilt trim from Sascha Brastoff, the treasures of that period are of little intrinsic value. They're just some molded earth sealed with a few nonprecious minerals. Although pottery is currently enjoying a collector/decorator revival, the worth of these once insignificant objects is best measured in terms of the pleasure they give to those who use, collect, or simply admire them. The fact that after all this time they are being used, collected and remade confirms their relevance to the way we live now.

For years collectors had been baffled: despite their best efforts they had been unable to learn anything about the creator of the pottery signed "Barbara Willis" that some of them prized. Then, in 1995, a woman in her seventies wearing a straw hat over bright red hair pointed to a vase at a Los Angeles flea market and said: "That's mine. I'm Barbara Willis. I made that." It turned out that Ms. Willis had closed her North Hollywood pottery in 1958 and was living happily in Malibu. After her "discovery" she began producing again, hand-thrown pieces this time, but in the same signature combination of intense glazes and exposed

Is There Lead in California Pottery?

The answer is yes. But you can use California Pottery if you're sensible about it. There is no reason to fear that admiring, living with, or even, in extreme cases, fondling old pottery will be harmful to your health even if it does contain lead. But when it comes to using it for food, remember the following guidelines: since it takes time for lead to leach out of glazes, avoid using pottery for acidic foods like fruit juices, tomatoes, pickles, coffee, and wine. Use pottery for serving, but never store food in it. And do not microwave food in it.

Although federal regulations have substantially reduced the danger from lead in new dinnerware production, even many of today's glazes are achieved through the use of lead. As surfaces become abraded, cracked, or crazed the lead can leach out of dishes and into foods and beverages over a period of time.

Uranium oxide was formerly used in red, orange, and yellow glazes, including those made by Bauer, Catalina, and Vernon Kilns. As for Fiesta, the Homer Laughlin Company of Newell, West Virginia, was using much of America's uranium supply for its glazes until 1943, when the Federal Government confiscated its stock of the radioactive mineral, leading the company to announce: "Fiesta Red has gone to war."*

The following guidelines are from the Web site of the nonprofit organization Environmental Defense:

- Don't store food or drink in questionable china pitchers, bowls, etc.
- Don't serve highly acidic food or drink in questionable china, especially to children.
- Don't heat or microwave in questionable china.
- If the glaze is corroded, or if there is a dusty or chalky gray residue on the glaze after the piece has been washed, don't use it. This type of china could be dangerous.

* In a profile of James L. Acord Jr., the creator of "nuclear sculpture," including the *Fiesta Home Reactor*, Philip Schuyler reported that "while waiting for his chance to work with weapons-grade plutonium, Acord learned to make do with a different radioactive source material: Mango Red Fiesta pottery." Profiles: "Moving to Richland—I," *The New Yorker*, October 14, 1991, p. 59. That should not be surprising since, according to Schuyler, "before the development of the atomic bomb the only proven use for uranium was in the decorative arts." Profiles: "Moving to Richland—II," *The New Yorker*, October 21, 1991, p. 62.

How to Test Your Pottery

Lead in pottery can be tested at home by using a simple yes/no procedure that reveals whether or not the surface tested contains more than the Food and Drug Administration's maximum allowable content (0.5 parts per million for cups, 3.0 parts per million for plates). You can test at home to determine whether lead is leaching from your dinnerware by using any of several home test kits, among them:

LeadCheck Swabs
P.O. Box 1210
Framingham, MA 01701
(800-262-LEAD)
www.leadcheck.com

Know Lead Kit
Carolina Environment
P.O. Box 26661
Charlotte, NC 28221
(800-448-LEAD)
www.knowlead.com

top
Brayton-Laguna Pottery, Laguna Beach
Plates. c. 1930.

above
H. F. Coors China Company, Inglewood
Custard cups. c. 2000.

below
H. F. Coors China Company, Inglewood.
c. 1999.

Gaetano Pottery, South El Monte.
c. 1999. Dishes à la Carte. Glendale.

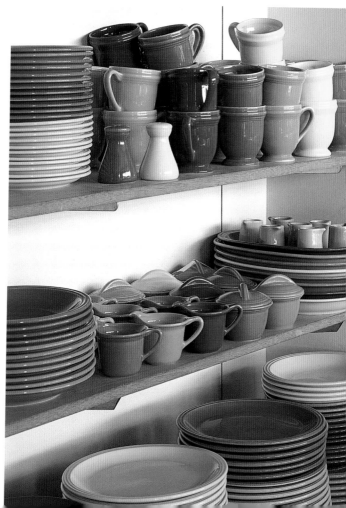

THE END OF THE RAINBOW

bisque that characterized her production pottery more than fifty years ago.

The current revival of interest in pottery has kept Heath Ceramics of Sausalito in good health under the direction of its founder, Edith Heath. It continues to make dinnerware for the home and for restaurants, as well as the architectural tile for which it is equally well respected .

Of the big companies whose work Peter Brenner and I have shown here, only Gladding, McBean (now owned by Pacific Coast Building Products, Inc.) remains, in Lincoln, California. Vernon Kilns closed in 1958; Bauer closed in 1962; the Franciscan Pottery division of GMcB (by then under separate ownership) closed in 1984. Metlox Potteries stayed in business until 1989. In addition to continuing to make architectural terra-cotta, GMcB has reissued—in some twenty-five glazes—large garden pieces from molds it originally created more than three-quarters of a century ago. It has been making oil jars (think of amphorae with flat bases for setting on patios instead of the pointed bottoms that allowed them to be stuck into the ballast of Roman ships), urns (footed plant holders), pedestals (for planters and statuary), and other ceramic objects. Some of the unornamented large pots are reminiscent of the work of the J. A. Bauer pottery, while others bear classical or early-twentieth-century ornamentation. All of the reissues carry a mark—the letters "GMcB" in an oval clearly incised in the clay—that identifies them as new and avoids confusion with Gladding, McBean's vintage products.

The resurgence of production and imports from other countries in the decades after World War II—abetted by a tariff policy designed to rebuild Japan and Germany as bulwarks against the Soviet Union—took an almost fatal

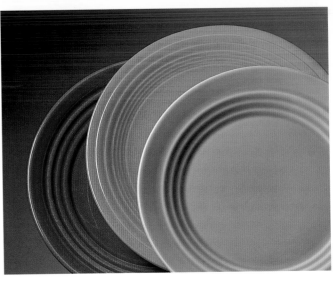

lunch plates. then and now
J. A. Bauer Pottery Co.,
Los Angeles
Ringware. c. 1932.
Homer Laughlin,
Newell, West Virginia
Fiesta. designed by Frederick Hurten Rhead. c. 1936.
Bosco-Ware, Thailand
"Ringware." c. 1996.

right
Gladding, McBean & Co., Lincoln

Jardiniere. elephant. oil jars. frogs.

Gladding, McBean & Co., Tropico

Bowl (center of cabinet top).

above
Taylor Tilery, Santa Monica

Tiletop table. c 1920s.

Malibu Potteries, Malibu

Small tile (center) and Galleon tile (upper right).

Franklin Tile Co., Lansdale, Pennsylvania

Galleon tile (lower right).

Malibu Potteries, Malibu

Conquistador and galleon tiles (center. outdoors). c. 1928.

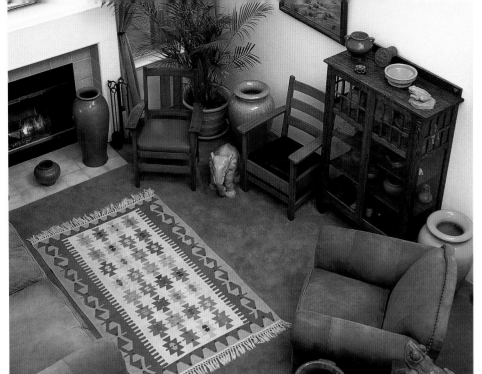

toll on California's potteries. The fever pitch of imagination and invention that characterized commercial California pottery production through the 1950s also waned and has not returned.

Colored pottery has, none the less, become a national and international phenomenon. Innumerable producers make it, some in the U.S., others in countries all over the world. Here in California it is being produced by the H. F. Coors China Company of Inglewood, the only large-scale producer of colored dinnerware in the state. Coors makes sturdy wares for restaurants and hotels and lighter-weight products for home use. Its dinnerware includes at least one solid-color line in several colors marked "COORS CHINA CO./INGLEWOOD, CALIF./U.S.A. ©," which is already showing up on the secondary market. Coors also produces hand-painted dinnerware, some of which is reminiscent of California Pottery designs from the 1930s. In 1997 Pfaltzgraff Pottery of York, Pennsylvania, boldly introduced its solid-color pastel Terrace colors—"Delicious

Architectural Pottery, Los Angeles

from left

"Peanut" planter. John Follis.
c. 1951. Red planter. Mary Kay
Austin. c. 1964. Inverted cone
planter. black, original chrome
stand. LaGardo Tackett. c. 1964.
White planter. Paul McCobb.
c. 1955. White low planter.
John Follis. c. 1961.

colors . . . exclusively ours!"[1]—more than fifty years after California's potteries first introduced theirs. Other recent examples come from Pier 1 Imports marked "Made exclusively for • Pier 1 Imports • Made in Italy • Fabriqué en Italie," and from Crate & Barrel: "BOSCO-WARE • QUALITY LIKE MOM MADE • MADE TO LAST BY SIGNATURE HOUSEWARES • DISHWASHER & MICROWAVE FRIENDLY • MADE IN THAILAND." Till Goodan's bronco riders and other practical mass-produced western-themed pottery is also popular once again. The irony is that with an original Till Goodan dinner service costing perhaps $2,400, these once popular-priced wares from the precomputer age are now most likely to be found in the new, fully-wired, retro-Western houses of dot-com entrepreneurs. The reissue of a few years back, whose mark makes it impossible to confuse with the original production, is less costly.

One effect of the growing popularity of California Pottery both for home decoration and for collectors is that more and more of it is coming out of cupboards, attics, and garages and onto the market. Having been produced in large enough quantities over a long enough period of time to ensure a sustained availability, the pottery's range also features enough elusive pieces to tantalize even the most tenacious collector. Whereas a Bauer plate might cost $35, a rare Bauer honey pot with its ultra-rare lid can cost more than $2,500. Although this raises the issue of values, that is a far too complex subject to be dealt with here.

But where is California Pottery to be found? You could start in your own kitchen or garden or those of your parents or grandparents. I've found that many collectors became familiar with California Pottery at home even if, like me, they didn't know at first that it was California Pottery. Whatever the source of your affinity for it, whether it be nostalgia, or color, or design, or some undefineable attraction, you should be able to whet your appetite at antique stores, especially

Mark: Bauer Pottery Company, Los Angeles
One of the marks used by a company making products inspired by vintage California Pottery, including Bauer ringware. c. 2000.

those that specialize in certain periods, such as the thirties or the fifties; at antiques malls, which are like neatly compartmentalized attics with price tags on everything; on specialized Web sites; and on Internet auctions.

Fortunately for the beginning collector and home decorator, California Pottery is usually easy to identify. Companies often marked their products, although there are notable exceptions, including Panama Pottery, Garden City Pottery, Bauer's plainware and Matt Carlton products, and many tiles. New vases marked "Bauer Pottery Company Los Angeles," ringware mixing bowls marked "Bauer Pottery 2000 Los Angeles," and ringware tumblers marked "Bauer Los Angeles" (original tumblers are unmarked) are unrelated to the J. A. Bauer Pottery Co.

Reproductions by several California artisans offer a degree of relief from the scarcity and high prices of vintage California Pottery tiles. Some, after originals by Catalina, Malibu, and other companies, are used for bathrooms, kitchens, and fireplace surrounds or can be placed in wrought-iron wall frames or tabletops. Although these tiles are often of excellent quality they cannot easily be confused with the originals, whose glazes seem to defy exact imitation.

Encouraging in all the revived interest in California Pottery is that almost half a century after its Golden Age it is now reclaiming a place in American homes. It pleases both purists, who need to be period perfect, and the impure, like me, for whom borders are meant to be crossed, as well as those who simply like beautiful objects. Some pieces from as far back as the thirties seem fresh enough to have been made yesterday and are living quite well, thank you, inside and outside refurbished homes from the fifties and sixties, as well as in some of today's most cutting-edge architecture.

California has been breaking the mold in all sorts of design—not only commercial pottery—for more than a century and hopefully will continue to do

Footnote
1 Full-page advertisement, *Los Angeles Times*, November 25, 1997.

so for years to come. But for those contributions to be appreciated, examples have
to be assembled, papers preserved, and memories documented; if not, more of the
evidence of our heritage will vanish—as so much has—into the landfills that are
the repositories of an otherwise disposable culture. Fortunately collectors, because
of their peculiar passions, have become the personal curators of California's pottery
history. They have taken objects that, when seen piecemeal, are just plates and
planters and provided a context in which they can be seen as valuable expressions
of our society. The current appreciation of vintage California Pottery and of its
place in American design history would not have been possible without those
obsessed men and women. Without them—and especially those who so gener-
ously opened their collections to Peter Brenner and me—this book would not
have been possible.

Pottery Marks

Brayton-Laguna Pottery, Laguna Beach

Catalina Pottery, Avalon

Architectural Pottery, Los Angeles

California Faience, Berkeley

Franciscan Ware, Los Angeles
(Gladding. McBean & Co.)

J. A. Bauer Pottery Co., Los Angeles

California Clay Products Co., South Gate

Garden City Pottery, San Jose

Gladding, McBean & Co., Lincoln

Pacific Pottery, Los Angeles

Vernon Kilns, Vernon

designer Jane Bennison

Heath Ceramics, Sausalito

Padre, Lincoln Park

Vernon Kilns, Vernon

designers May & Genevieve Hamilton

Metlox Potteries, Manhattan Beach

Vernon Kilns, Vernon

Barbara Willis, North Hollywood

Acknowledgments

Thank you to:

Jack Chipman, Clare Graham, and Bob Hutchins for bringing their knowledge and clearheadedness to those parts of the manuscript they read. Any remaining errors, omissions, or infelicities are, of course, solely my responsibility.

—Bill Stern

And to those who allowed parts of their collections and/or their homes to be shown in this book:

Juan Bastos/Tom Parry
Steven Beals
Charles R. Bove
Carmen Brady/Pierre Allaud
Mark Brandt/Mike Showalter
Bob Breen/Clare Graham
Susie Tompkins Buell
Steve Cabella
Jack Chipman
Dean Crane
Jim Drobka
Deleen Enge
Dan Fast
Janet M. Gleason
Dan Huffman
Doug Hamilton
Bob Hutchins
Steve Johnson
Norman Karlson
Diane Keaton
Jerry Kunz

Max Lawrence
Ronald Paige Long
Margueritte and Harrison McIntosh
James Marrin
Museum of California Design
Naomi's of San Francisco
Daniel Ostroff
Mary Quirk/Bill Steinberg
Maureen Ryan/Larry Davis
Andy Stevens
Susan Strommer/Mark Wiskow
Steve Temme/Dan Craver
Mitch Tuchman
Li Vaughn
Cristi Walden
Kevin West/Bob Hansen
Barbara Willis

And thank you to:

Al Albert
Jane Bennison
Irene Borger
Michael Brayton

Bertram Brock
John Brooder, Heath Ceramics
Denny Burt
Steve Conti
Royce Diener
Dishes à la Carte
Doris Dohn
Harvey Duke
Bruce Emerton
Fat Chance, Los Angeles
Andy Hackman, Out Side
Edith Heath
Ron Hillman, Antiques & Objects
Melinda Hurst
Edan Hughes
Brian Kaiser
Anton and Larry, OK
Osamu Otashi
Mary Phillips
George Piazzi
Malinda Pretz
Steve Soukup
Kevin Souza
Barbara Voss

Wallace China Co., Huntington Park
Color-chart plates used by
salesmen when taking orders
(middle. 1934: top. bottom. 1936).

Sources

Some Producers of California Tile Reproductions and Original Designs

Marlo Bartels
Marlo Bartels Studio
2307 Laguna Canyon Road #7
Laguna Beach, CA 92651
949/494-4408
marlobartels.com

Terracraft by Richard Compton
On sale at:
Gamble House Bookstore
4 Westmoreland Place
Pasadena, CA 91103
626/449-4178

And at:
Craftsman Home
3048 Claremont Avenue
Berkeley, CA 94705
510/655-6503

Richard Keit/Mary Kennedy
RTK Studios
206 Canada Street
Ojai, CA 93023
805/640-9360

Will Richards Art Studio
P.O. Box 494
Avalon, CA 90704
310/510-1714

Diane Winters
2547 8th Street #33
Berkeley, CA 94710
510/533-7624

Current Production Tiles, Dinnerware, and Gardenware

The Blue Pear
1313 N.W. Glisan
Portland, OR 97201
403/227-0057

H. F. Coors China Company
Restaurant China (wholesale only)
8729 Aviation Boulevard
Inglewood, CA 90301
310/338-8921

Dishes à la Carte
Outlet stores for:
H. F. Coors, Laurie Gates, Gaetano
5650 West Third Street
Los Angeles, CA 90036
323/938-6223

113 W. Los Feliz Road
Glendale, CA 91204
818/240-2329

1629 Abbott Kinney Boulevard
Venice, CA 90291
310/396-0023

Gaetano America
(wholesale only)
1854 Belcroft
South El Monte, CA 91733
626/442-2858

Gainey Ceramics & Fiberglass
Gardenwares
1200 Arrow Highway
La Verne, CA 91750
909/593-3533

Heath Ceramics
400 Gate 5 Road
Sausalito, CA 94965
415/332-3732

Laurie Gates Designs
Metlox Lotus pattern and
original designs (wholesale only)
1936 Pontius Avenue
Los Angeles, CA 90025
310/575-1418

Miller Pollard
2575 N.W. University Village
Seattle, WA 98105
206/523-3950

Mission Tile West
853 Mission Street
South Pasadena, CA 91030
626/799-4595
sales@missiontilewest.com

Mortarless Building Supply Corporation
(new and vintage tiles)
2717 Fletcher Drive
Los Angeles, CA 90039-2412
323/663-3291
www.original-vintage-arttile.com

OK
Edith Heath Ceramics
8303 West Third Street
Los Angeles, CA 90048
323/653-3501

Out West Trading Co.
Reissue Bauer pottery
(wholesale only)
213/840-3779

Terra Verde Trading Co.
Edith Heath Ceramics
120 Wooster Street
New York, NY 10012
212/925-4533

Vessel Pottery
Architectural Pottery
Reproductions
11808 Rancho Bernardo Road
Suite 123
San Diego, CA 92128
858/385-1960

Some California Pottery Internet Sites

A number of these sites carry links to other sites that, though not California Pottery specific, include information on, or offerings of, California Pottery:

Bauer Pottery
www.bauerpottery.com/

The Bauer Pottery Page
users.aol.com/Stadelbach/BauerPottery.htm

Franciscan Discussion Forum
www.egroups.com/mygroups
(register for ".gmcb" group)

Franciscan Web Site
www.gmcb.com

Metlox.com
www.metlox.com

The Metlox Nuts
home.earthlink.net/~ge1228/index.html

Vernon Kilns Plaid Dinnerware
www.geocities.com/~vernonplaid/

Vernon Kilns Pottery
www.speakeasy.org/~duchess/pottvk.html

Vernonware Website
www.colling.com

Winfield Pottery
www.jps.net/clowder/china.htm

Some Internet Auction sites

eBay Auctions:
www.eBay.com

RagoArts.com:
www.ragoarts.com/

Treadway Gallery:
www.treadwaygallery.com/

Specialized Antiques Stores

Antiques & Objects
446 S. Fair Oaks Avenue
Pasadena, CA 91105
626/796-8224

California Connection
1716 Westheimer Road
Houston, TX 77098
713/529-8340

Denny Burt Modern Antiques
7208 Melrose Avenue
Los Angeles, CA 90046
323/936-5269

Laguna
116 S. Washington Street #2
Seattle, WA 98104
206/682-6162

Mark Jaeger Antiques
1012 Mission Street
South Pasadena, CA 91030
626/799-2640

Naomi's of San Francisco
1817 Polk Street
San Francisco, CA 94109
415/775-1207

The Old California Store
1528 East Thompson Blvd.
Ventura, CA 93001
805/643-4217

Wells Antiques
2162 W. Sunset Boulevard
Los Angeles, CA 90026
213/413-0558

Index